GRAND CANYON CALLING

An Artist's Relationship with the Grand Canyon

SERENA SUPPLEE

LILY CANYON BOOKS
MOAB, UTAH

©2016 Lily Canyon Books

First Edition 2016

Art Director, Artist, Author: Serena Supplee
Photographers: Bill Godschalx, Patrick Paul René

Printed in Canada

Published by:
Lily Canyon Books
P.O. Box 579
Moab, Utah 84532 U.S.A.
www.serenasupplee.com

Library of Congress Control Number: 2016936171

ISBN: 978-0-9864200-3-0 (2500 paperback)
ISBN: 978-0-9864200-4-7 (250 cloth)

CONTENTS

INTRODUCTION

My visions of the Grand Canyon start by drawing what calls to me and then develop into watercolor or oil paintings. This collection of paintings is from 2006-2015.

Through my artwork I wish to:

capture the eye

excite the mind

stir memory

feed the heart

This book is divided into four chapters to highlight my different perspectives of the Grand Canyon. Weeks of sketching and painting on the South Rim, months of rowing my boat on the river, days of hiking and backpacking the trails, and annual winter retreats at Phantom Ranch add up to years of my life lived in the Canyon.

HANGIN' ON THE RIM

Often before trips into the Canyon, and through the six years plein-air painting for the Celebration of Art hosted by the Grand Canyon Association, I had many opportunities to connect with visitors and to breathe in the range of views on the South Rim.

Life is made from the special moments. During the quick draw of 2014, I saw an outcropping as a snake and looked to the other side of the canyon and saw the same shape. A Hopi friend came up and said, "You are painting me. I am the snake clan." He shared his story of the Hopi boy in the log going through the Canyon all the way to South America, bringing water to his people on his return. It was a great story to hear as I was painting.

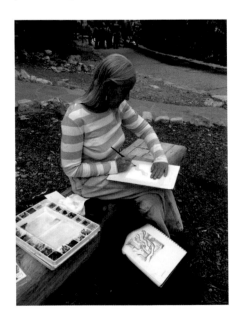
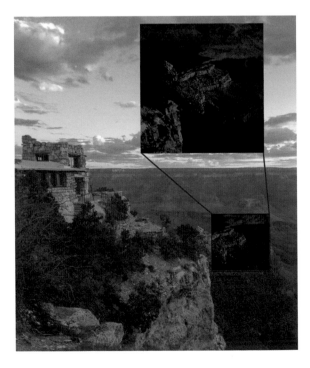
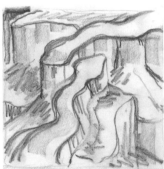
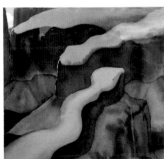

LOVE A RIVER TRIP

The Colorado River is the lifeblood of the Grand Canyon and has become a personal analogy for my own life. I look at the river metaphorically as my life path: with rapids or obstacles of many sizes, flowing through gentle meanders and times when I could be a braided channel, dividing my energy. Many times in the Inner Gorge all forces are going in one direction. What a focus of energy.

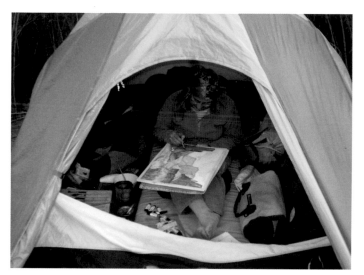

On a river trip, painting out of the wind.

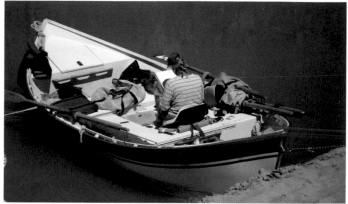

Drawing and painting on my boat is so fun, lots of flat space around me for my art stuff. River sounds and smells are a comfort zone of inspiration.

Rowing my boat is like being on a fluid road. A shift happens, another awareness. I like feathering my oars while I row without a sound, quietly in and out of the water, being a part of the river.

Scouting a rapid and choosing my line can be like choosing a strong line or movement in my painting.

My passion for rowing rivers spills into the fluidity of my paintings.

TRAIL TRAVEL

I love the views from the Tonto Platform, the middle perspective canyon in all directions with the river below. I am so fortunate to have backpacking friends that will stop and wait for me to sketch.

On the trail one day, I came around an outcropping face-to-face with a bighorn sheep ram. I stood still and in my gentle, soft, sweetheart voice spoke to him of his magnificence. I was so grateful when he found a safe way around me.

I'VE BEEN DOWN!

PHANTOM RANCH
GRAND CANYON

PHANTOM RANCH

The Inner Gorge is my lodestone. To hike the snowy trail down to Phantom Ranch on my annual retreat is always a gift.

I was kicked back on my boat, setting up my watercolors to "paint one," while the rest of my river trip companions walked the half mile to Phantom Ranch. Wanda, a "Rancher," noticed me doing what I love to do, painting the Inner Gorge. She asked if I'd be interested in doing a t-shirt design for Phantom Ranch. That was in 1995, the first of many years of having my art on a Phantom Ranch t-shirt.

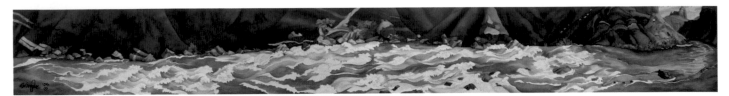

The Thick & Thin of It

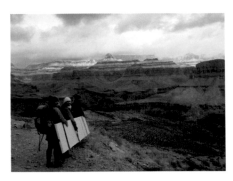

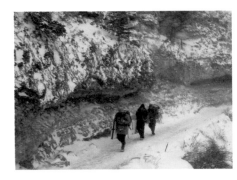

In my studio in 2005 using sketches that I did at the rapids, I painted "The Thick & Thin of It." This is a watercolor of Hance Rapid that is 9 ½ feet long and nearly 2 feet tall. With no space to store or display it at home, I drove it to the South Rim to search for a place to share this special painting. When I hiked down to Phantom Ranch there was the perfect spot in the Cantina above the windows. Friends hiked the painting down for me. Five years later friends carried "The Mighty Colorado," a 10-foot-long oil painting of Hermit Rapid, down to Phantom Ranch in a snow storm. The next day "The Thick & Thin of It" was carried out in the same foam crate, in the same storm.

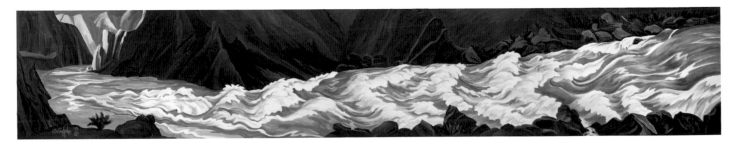

The Mighty Colorado

I feel the call of the Canyon because a part of my spirit is always in the Canyon.

HANGIN' ON THE RIM

the big view!

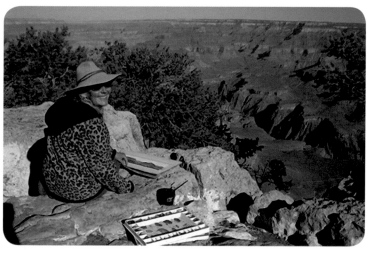

Serena on the rim

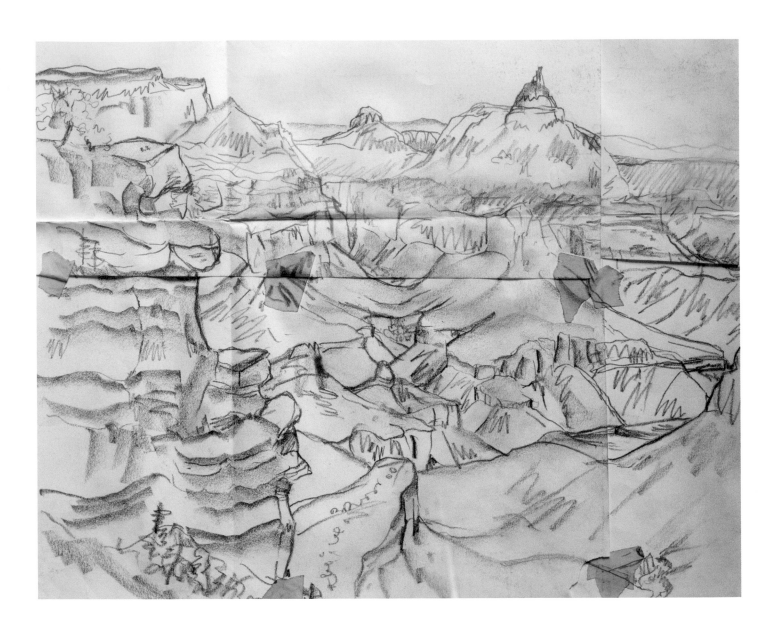

Vishnu Temple changes form from different viewpoints.

For the longest time I would start a drawing and it would run off the paper. Sometimes I would start over. Now I just tape another piece of my sketch book on and keep drawing until it feels complete to me.

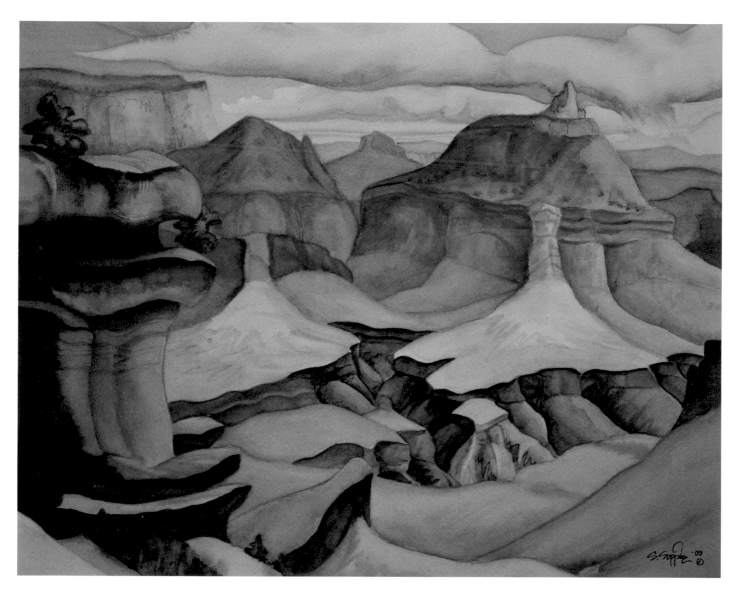

Baba Vishnu

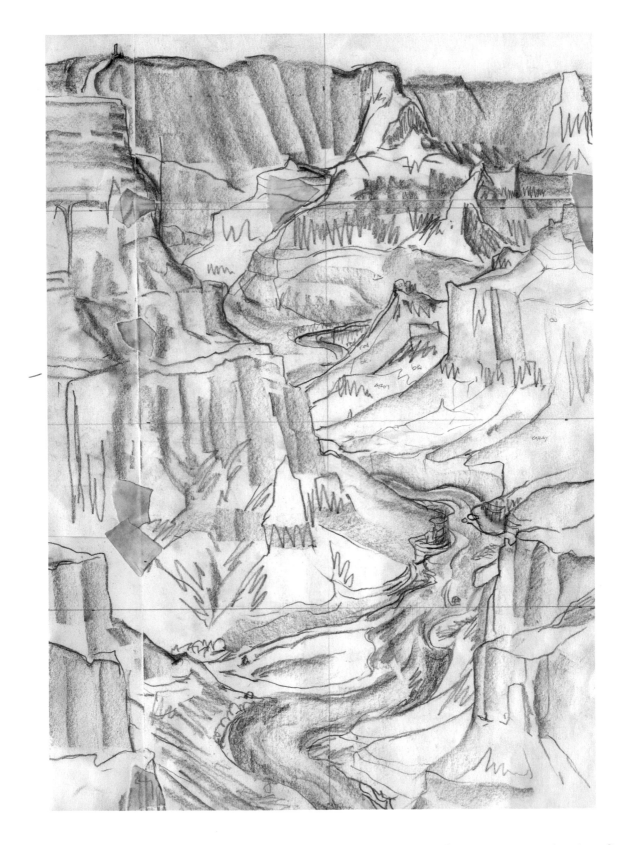

A wonderful Navajo man escorted me to the confluence overlook of the Little Colorado River and the Colorado River. What an amazing new view for me, all the way to the Desert View Watchtower and beyond.

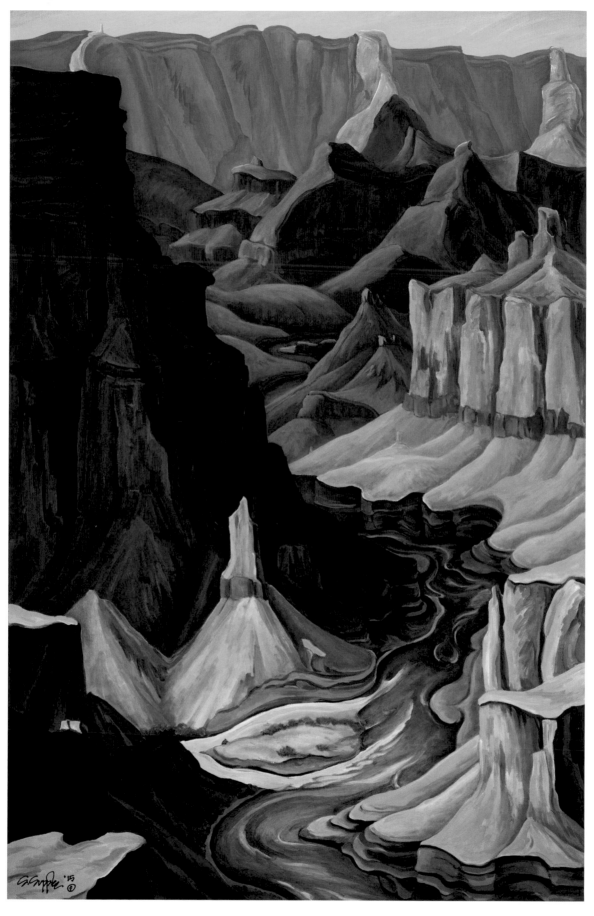

Magical Merger

oil 48" x 30"

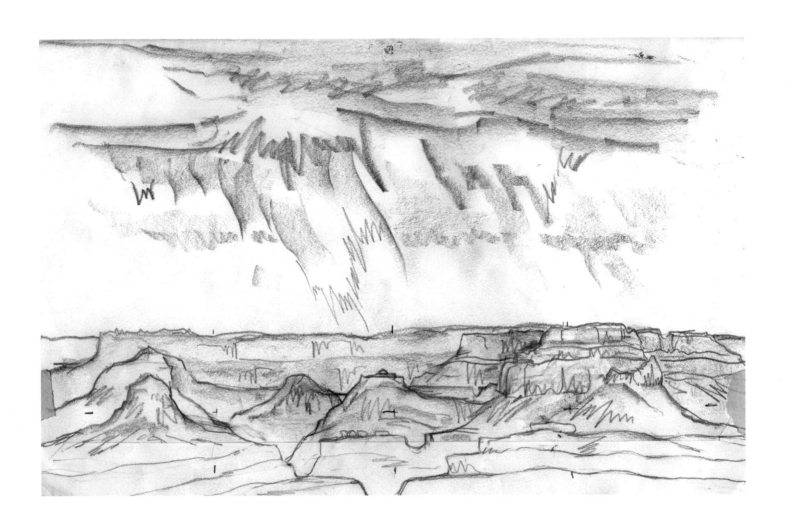

Storms blow over the Grand Canyon. I pray for rain to moisten the plants and ease survival. Sometimes it's just virga and sometimes rain will hit one side canyon and not another. Luck of the draw.

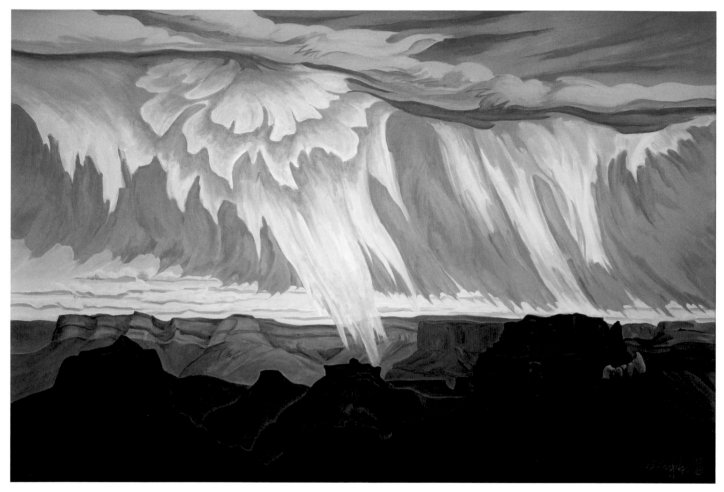

Touch & Go!

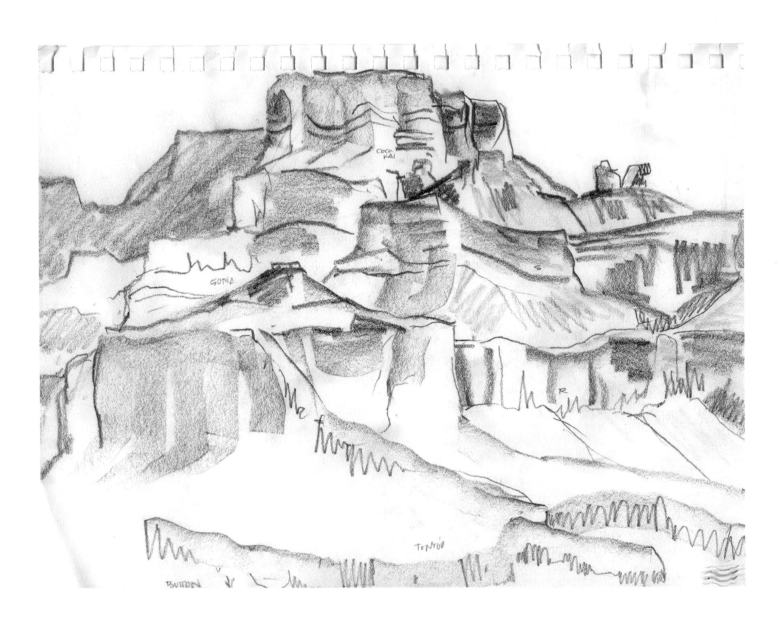

Often when I'm on the rim, I think about being in the Canyon. I like feeling immersed in it. I painted myself in that way.

The Inner Gorge is a lodestone to me.

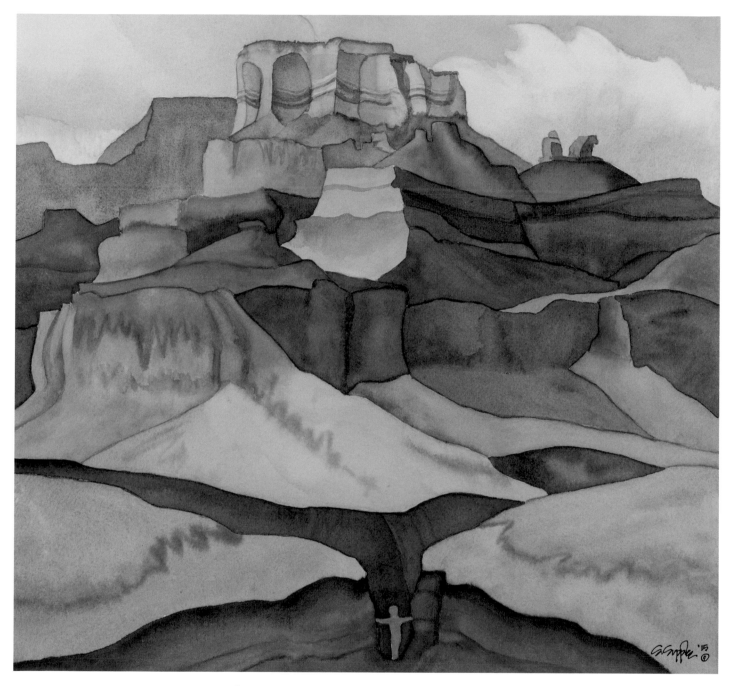

I'm in Grand Canyon

River in the Sky is what I call the Milky Way, a fluid arc across an infinite sky.

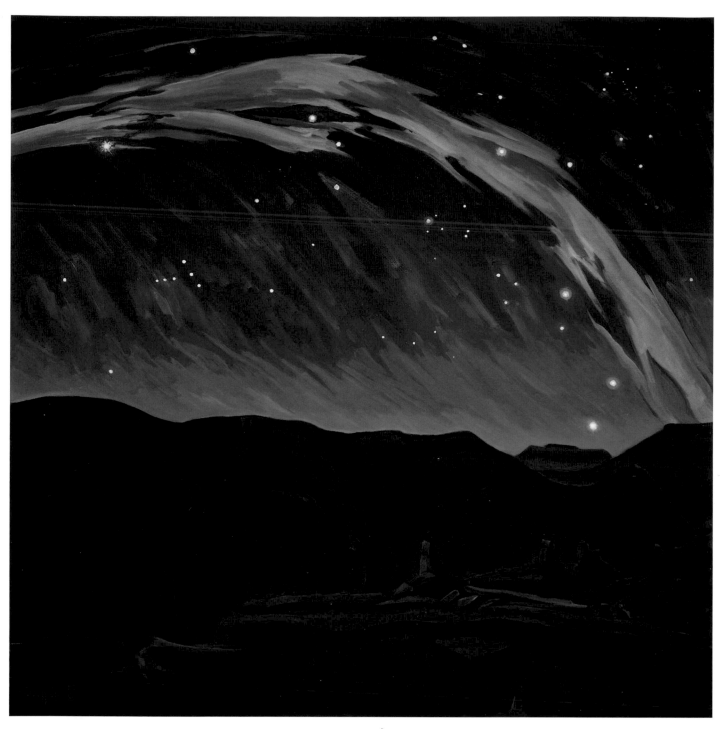

River in the Sky

oil 40"x 40"

When Grand Canyon is full of clouds it feels full of dreams to me.
New possibilities bubbling up to reality.

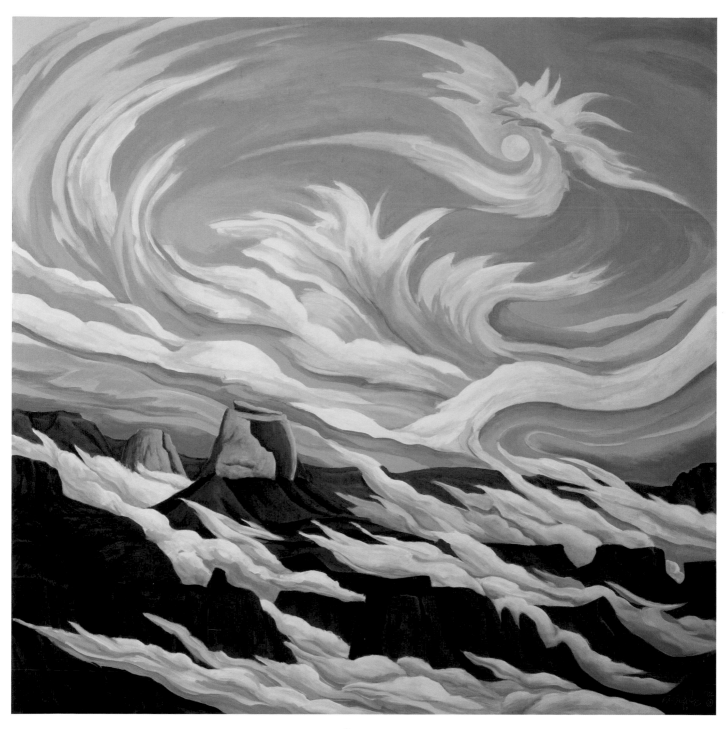

A Dreamy Day's Night

I drew the dead juniper outside the Hopi House and then went to Hopi Point to give it a beautiful backdrop. Merging Hopi-labeled spots on the South Rim.

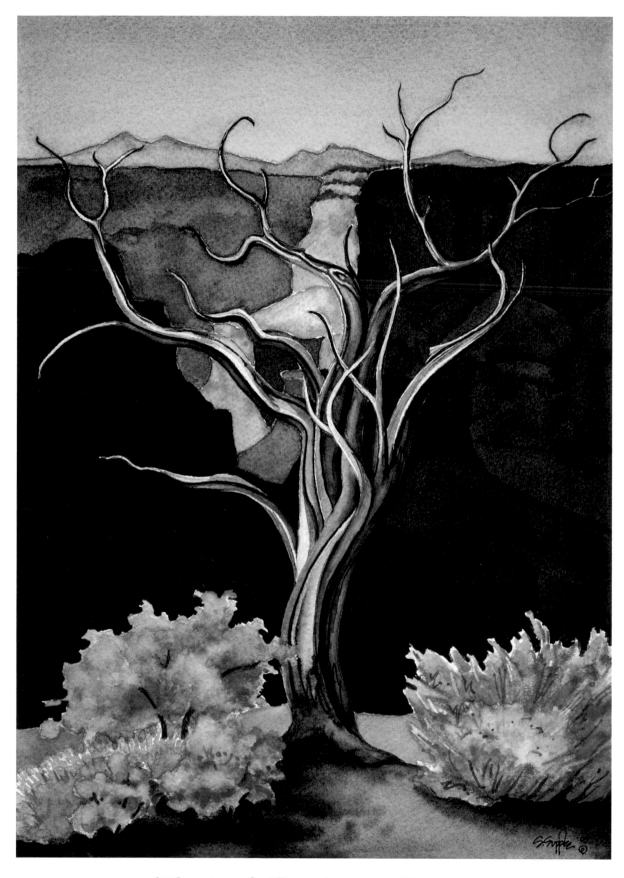

Poetic Twists & Turns

This drawing from Hopi Point, pointing west, includes all the geologic layers of the Grand Canyon.

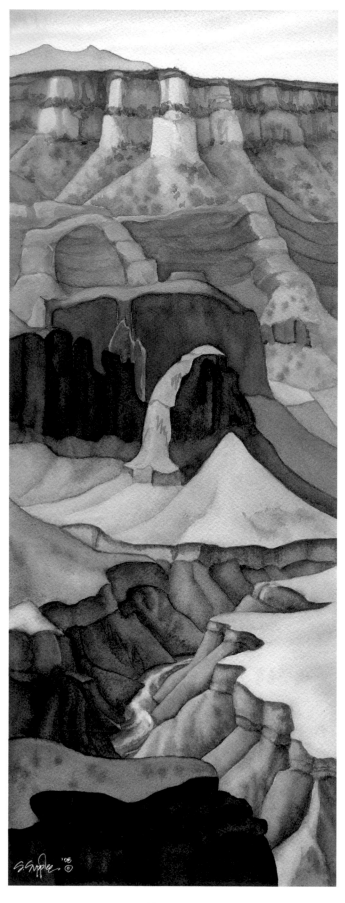

Distinct Destiny

watercolor 17½" x 6½"

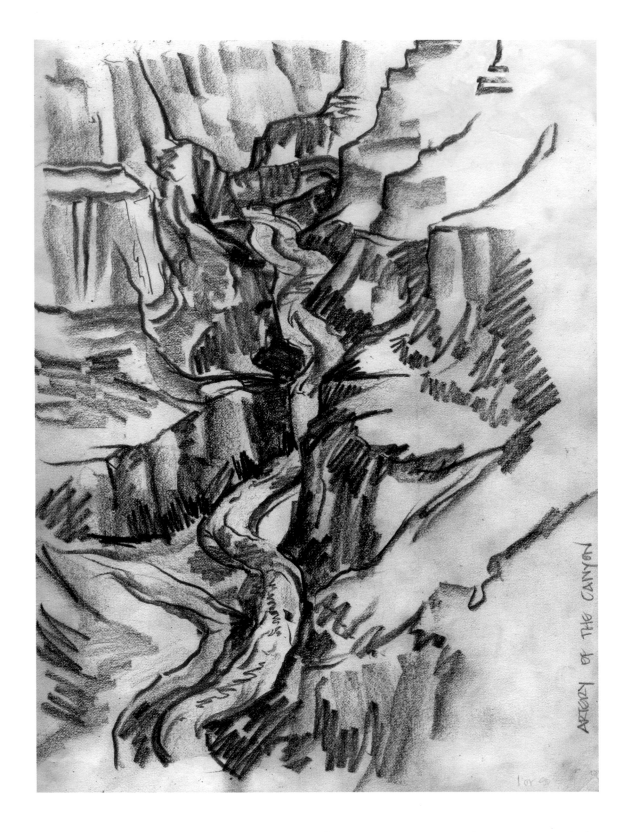

ARTERY OF THE CANYON

Feeling the vibrancy and power of the Canyon at Toroweap, while looking down at Lava Falls Rapid.

This painting was lost in Hurricane Ivan in 2004. It was painted in 2002, but included as a fond memory.

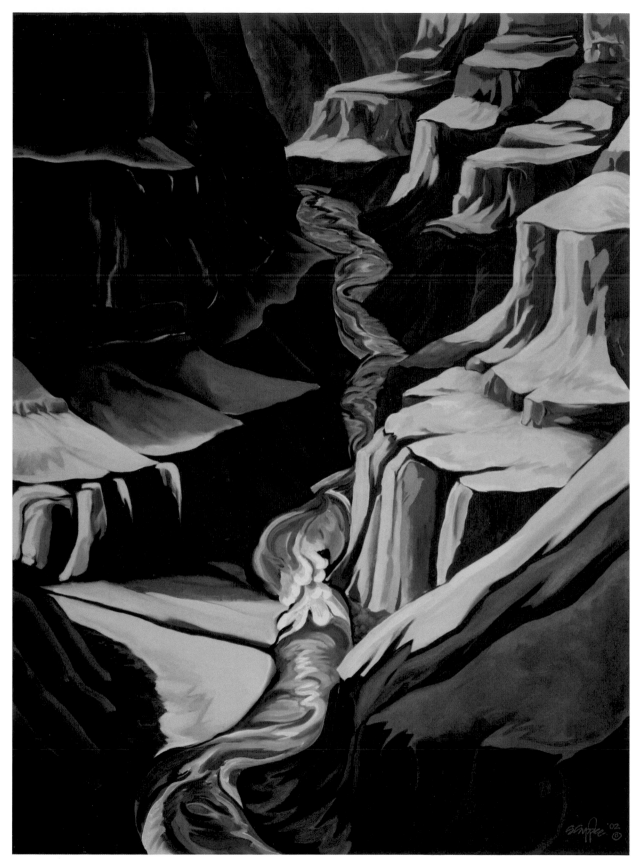

Artery of the Canyon

oil 72" x 48"

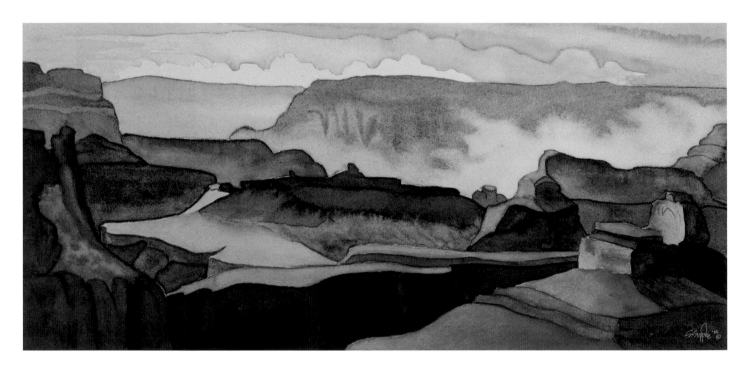

Big Dream Canyon

Expansive canyon evokes expansive thoughts.

watercolor 6½" x 14"

LOVE A RIVER TRIP

**the flow of the river
the flow of my life**

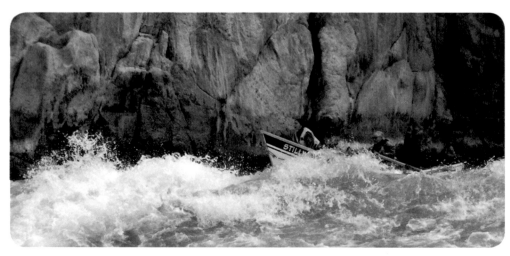

Serena rowing her dory

As I was covering the canvas with the first coat of paint, I saw the Milky Way taking form as a datura and a hummingbird. I went with it.

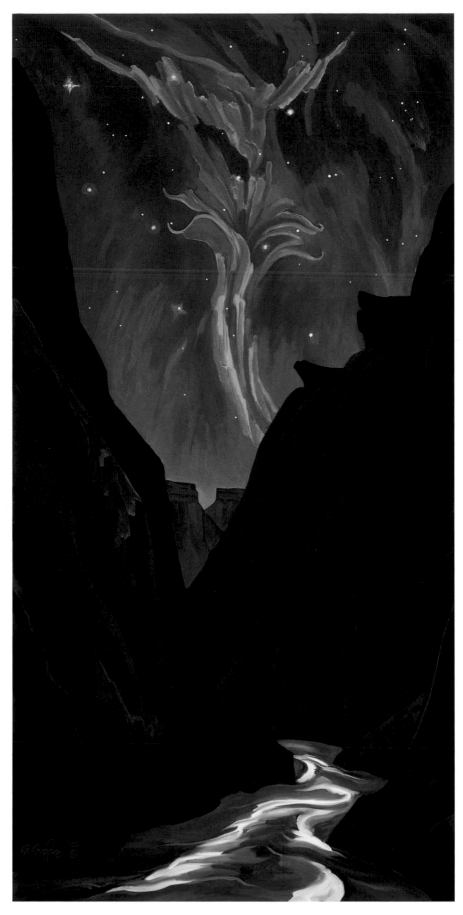

Canyon Magic

oil 60" x 30"

The classic downstream view from Nankoweap. I see all the meanders as a life path, things always take a turn or a bend, but it always works out. You always move downstream.

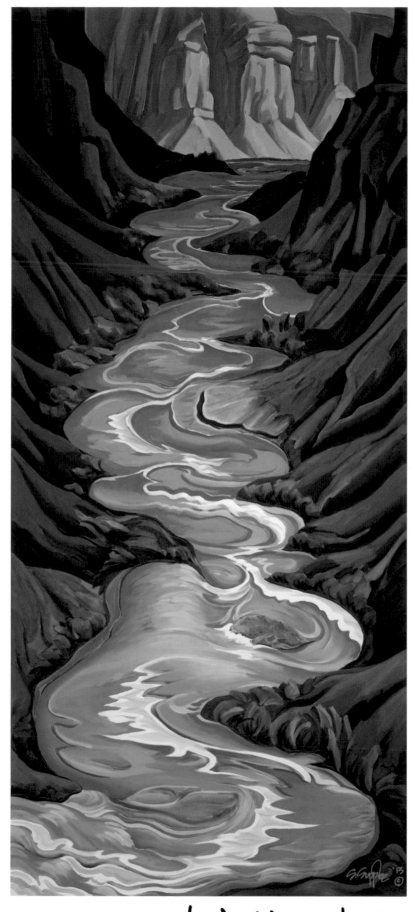

Monumental Meander

This is a series showing the Colorado River with different amounts of sediment in solution. The clear turquoise is water straight from the dam, the dull green has some sediment, and the rusty color is saturated with silt, clay and sand from upstream.

What color is the river? This is a question I ask myself often. When you look at the reflections from the sky and the cliffs, it brings even more options.

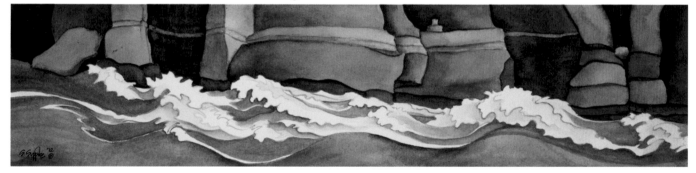

Turquoise Trail

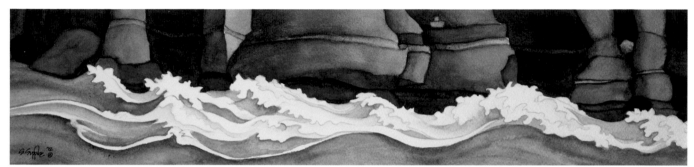

Serpentine Surf

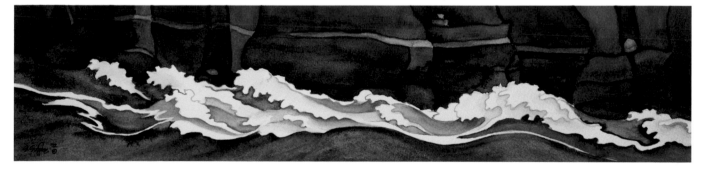

Rusty Run

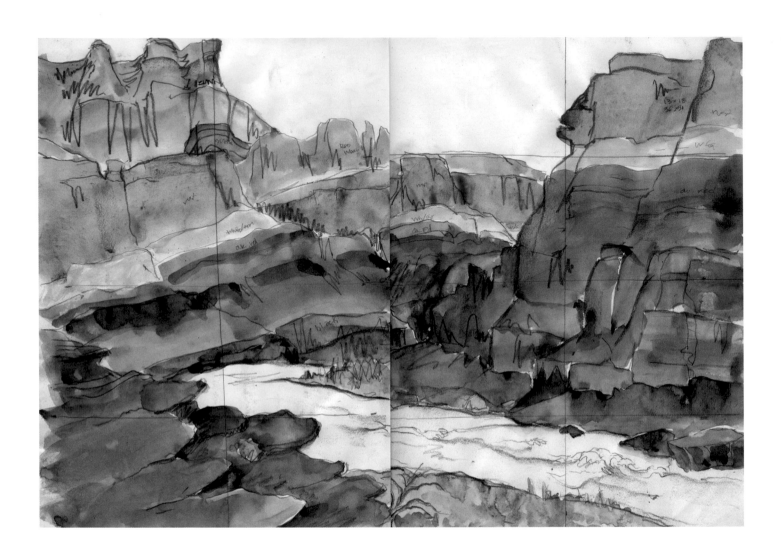

From Nevills Rapid you can see Zuni Point on the rim. This drawing is filled with watercolor to help me remember the super group layers when I came home to my studio to do the painting.

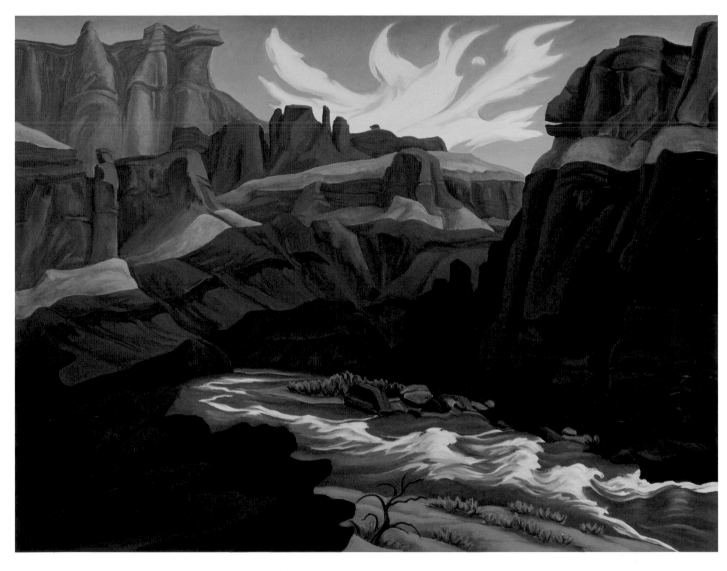

Red Rover Red Rover

The beautiful waves at the top of Granite Rapid. As I painted them, they started looking like flower petals, hence the title "Blooming Strength."

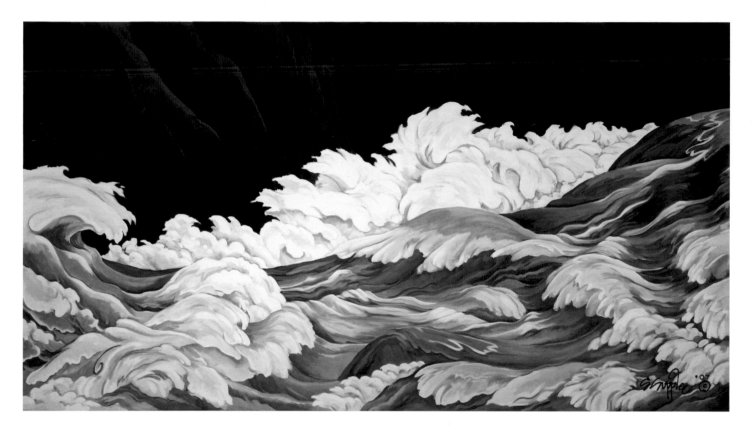

Blooming Strength

We were so fortunate to camp under an overhanging cliff. This was something I had waited many trips to do, made me feel like singing "Rockin' Robin."

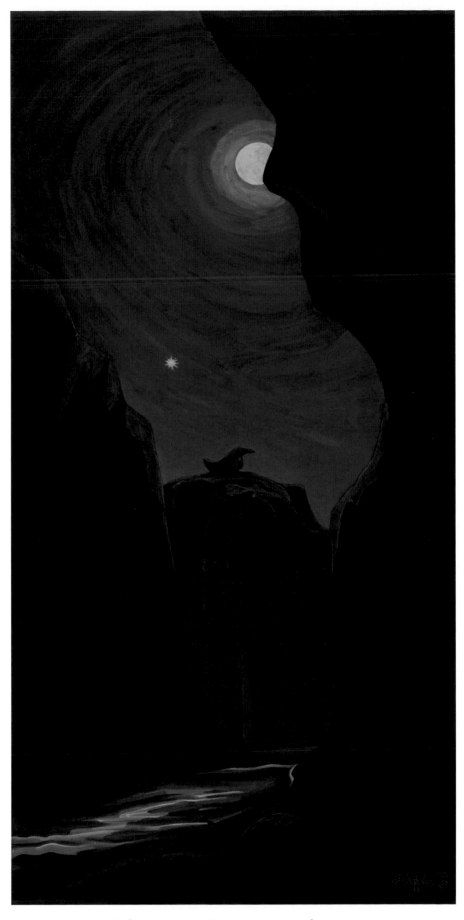

Momentous Moon

oil 48" x 24"

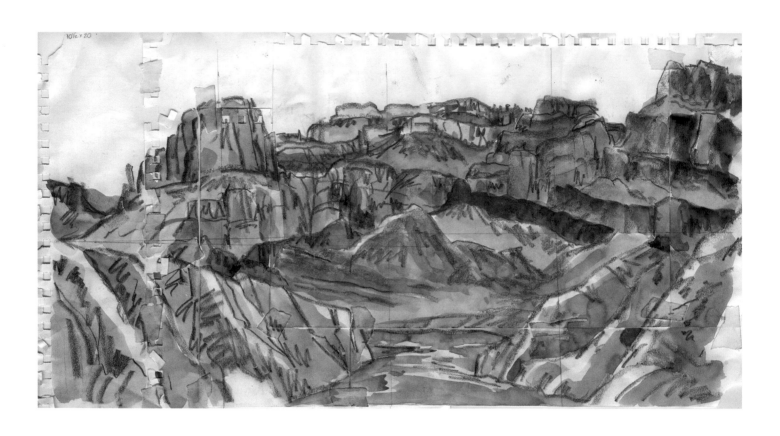

Another drawing colored with watercolor; enjoying the lower end of
the Inner Gorge, Shinamu drainage, Fan Island and the Powell Plateau.

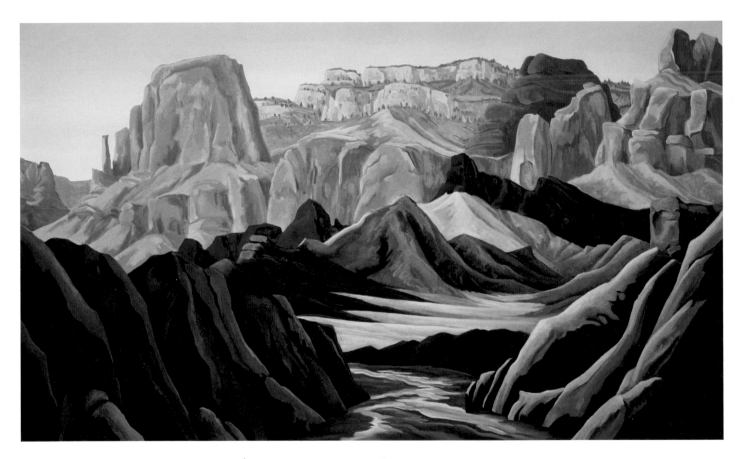

Hop, Skip & a Jump

oil 36" x 60"

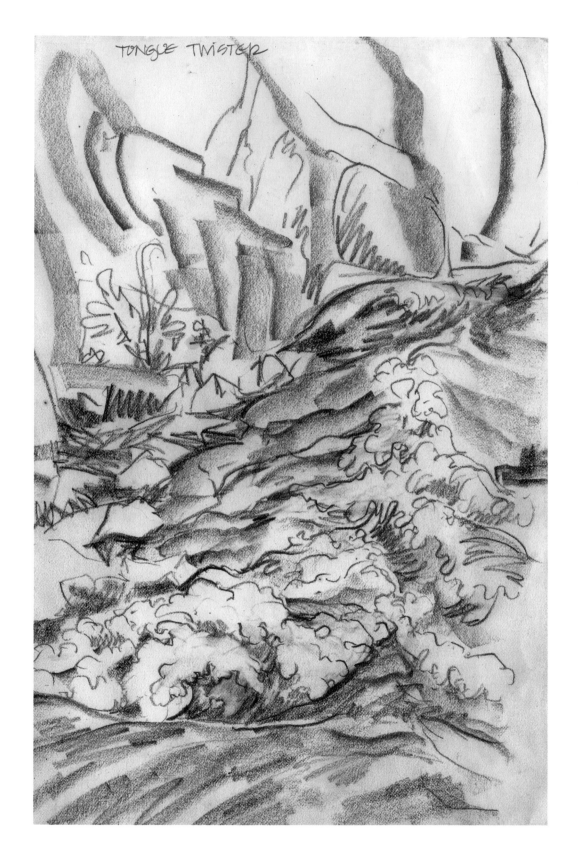

Horn Creek Rapid. Here we go!

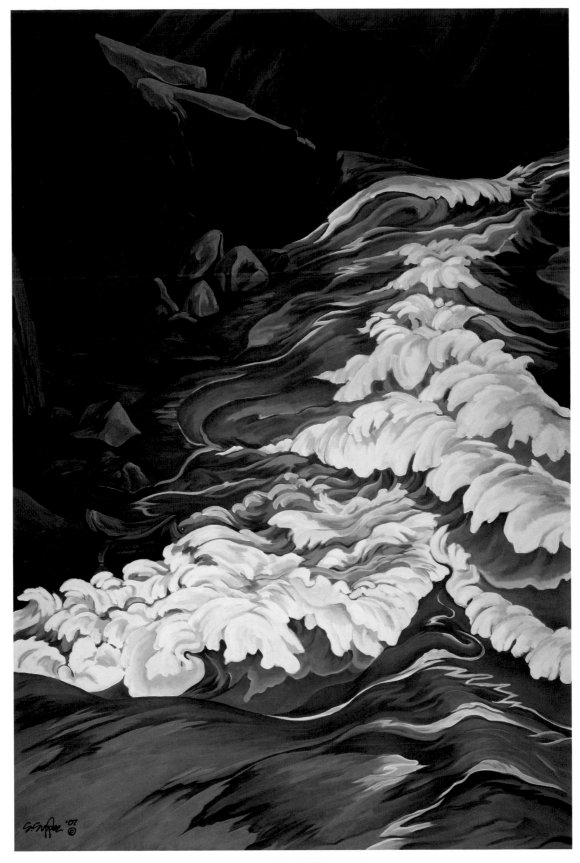

Tongue Twister

oil 66" x 44"

Looking down on the rapid as I scout.

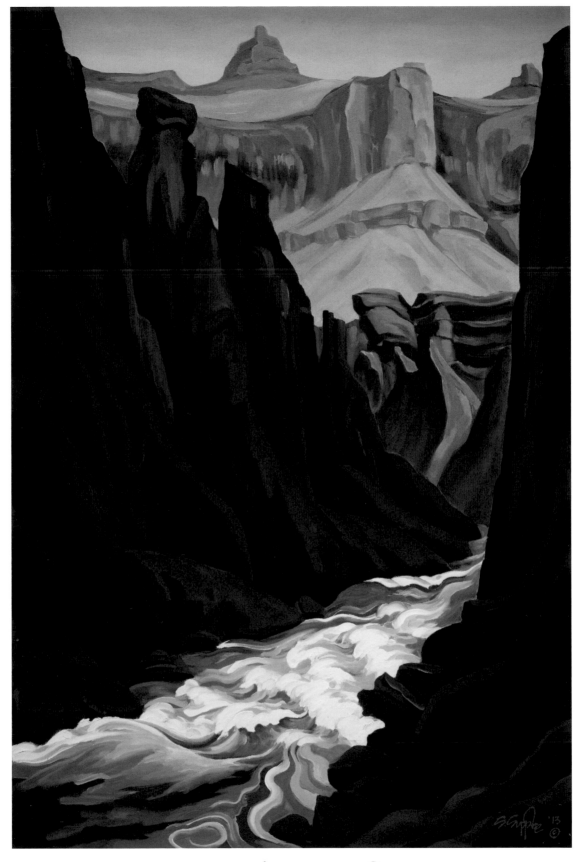

Rapids Ahead

They call this Owl Eyes, an amazing pair of caves in the Kaibab Limestone. Playing on the sound, figuring you can't have too many allies in life.

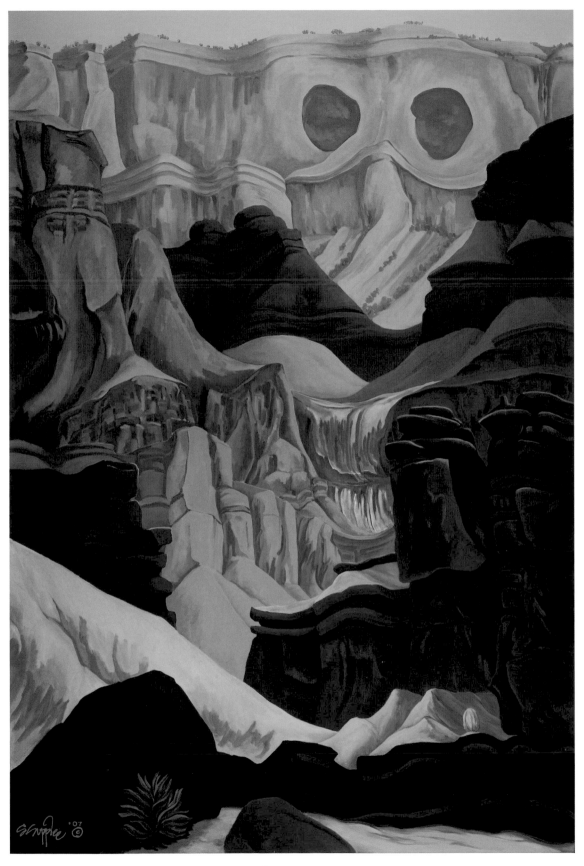

Allies

oil 66" x 44"

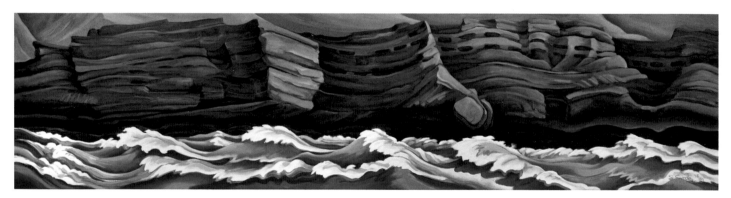

Beholden to the Golden

Muav Limestone parades a deluxe color combination at Fern Glen Rapid.

oil 16" x 64"

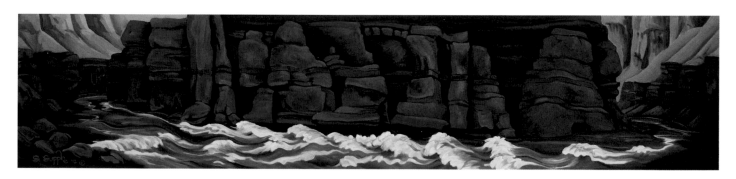

Ain't Gettin' Upset

Upset Rapid goes around a bend in the river. It's remarkable to look upstream and downstream at the same time.

A wonderful spot with my boat parked in the moonlight.

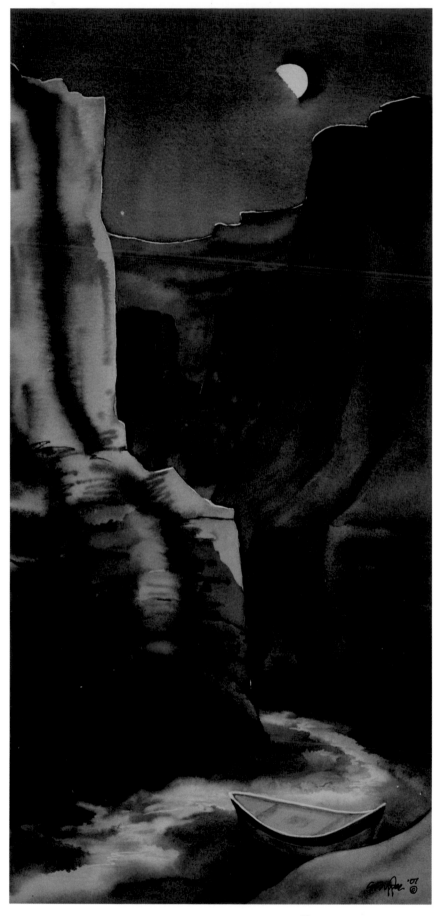

Boat & Beyond

The granite squiggles by the lower half of Crystal Rapid.
My eyes have a great time exploring.

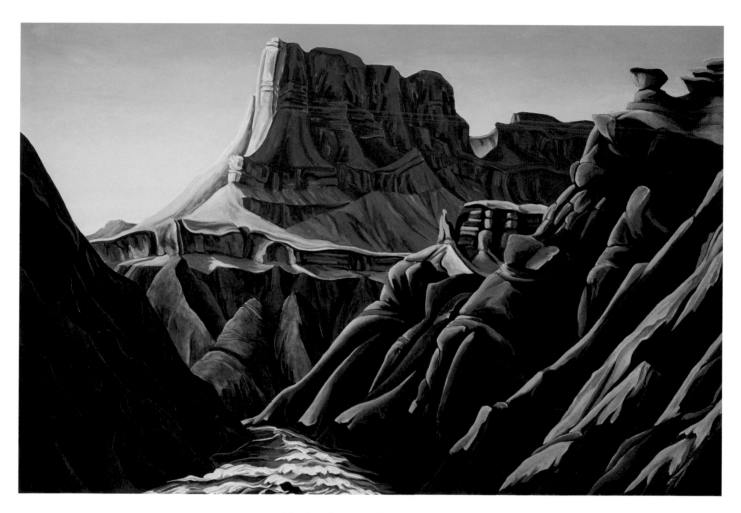

Violet Vitality

oil 40" x 60"

A favorite spot deep in the Canyon.

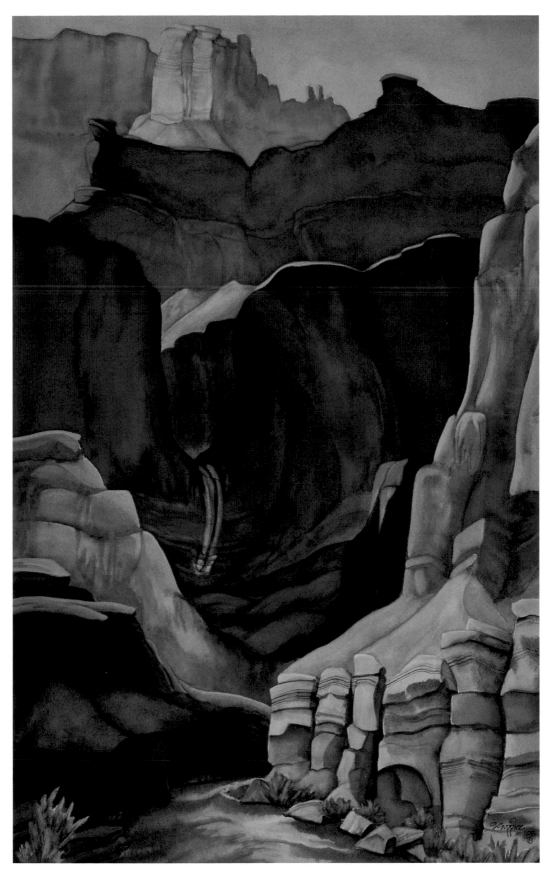

Rolling Stones

The crescent moon of new beginnings as the river moves along.

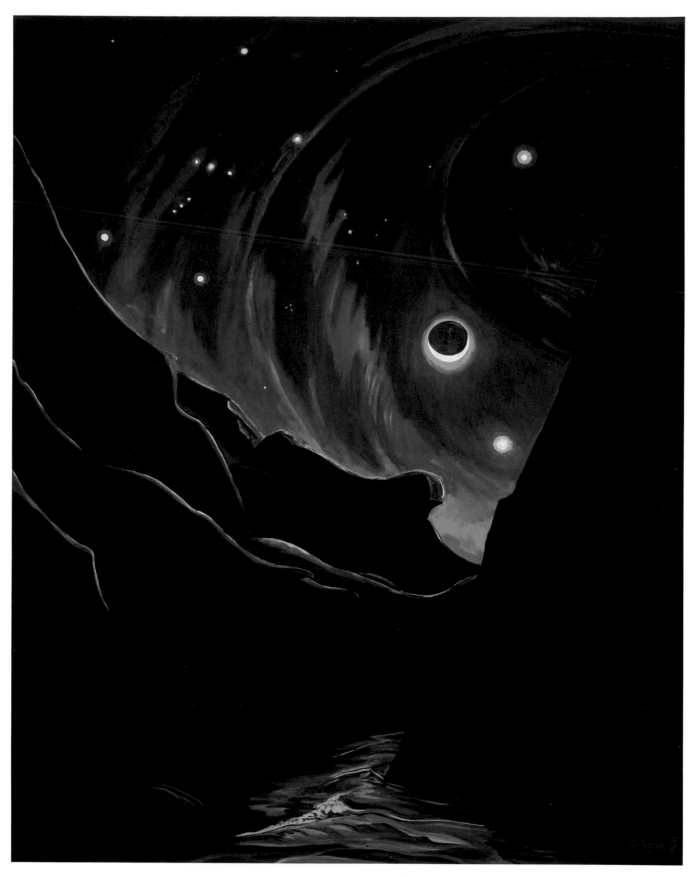

Downstream Dream

oil 50" x 40"

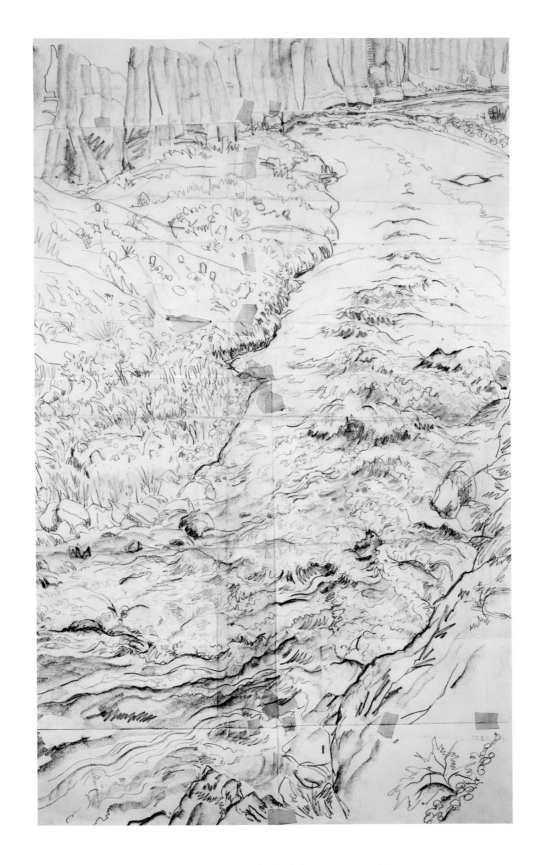

Lava Falls is powerful. Enter and hang on.

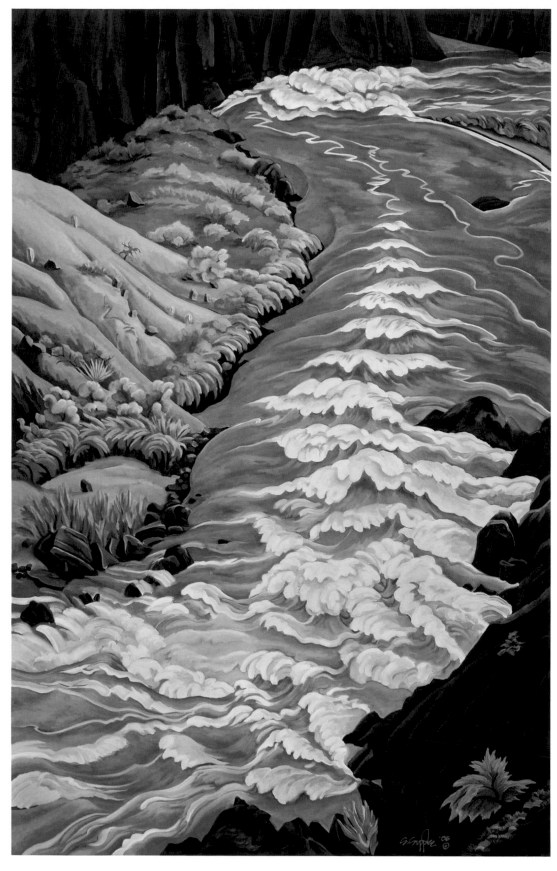

Run Lava Run

Lava Falls from the bottom. Waiting for your cells to settle again.

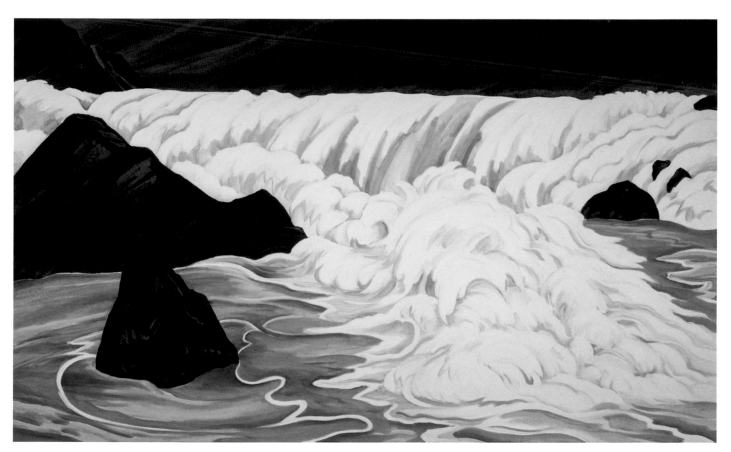

Lava Up

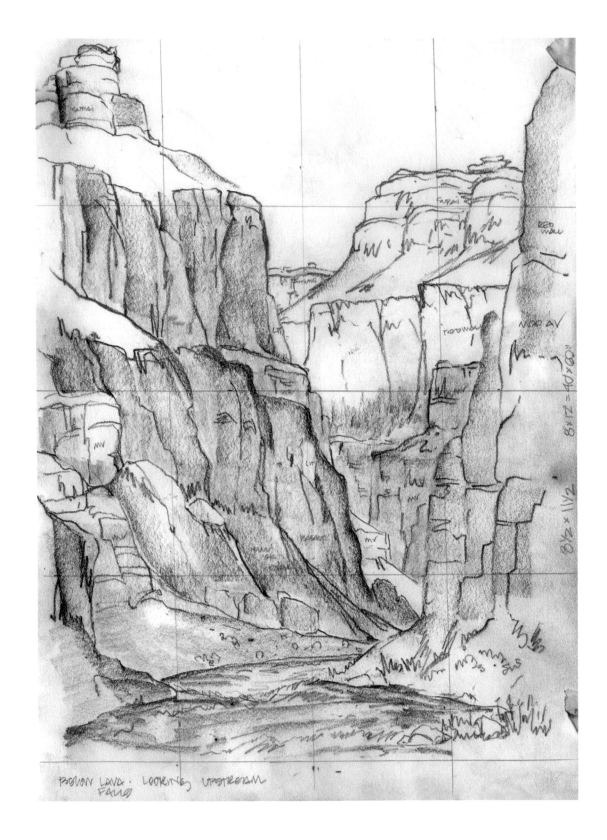

A lava flow a couple of miles below Lava Falls Rapid. Feeling vibrant from the experience of living in the Grand Canyon.

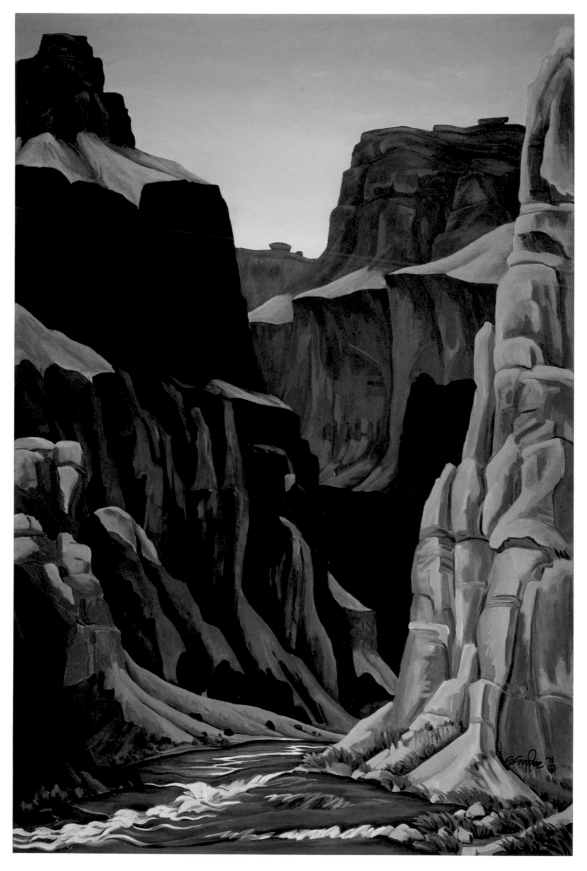

Classic Rock

oil 60" x 40"

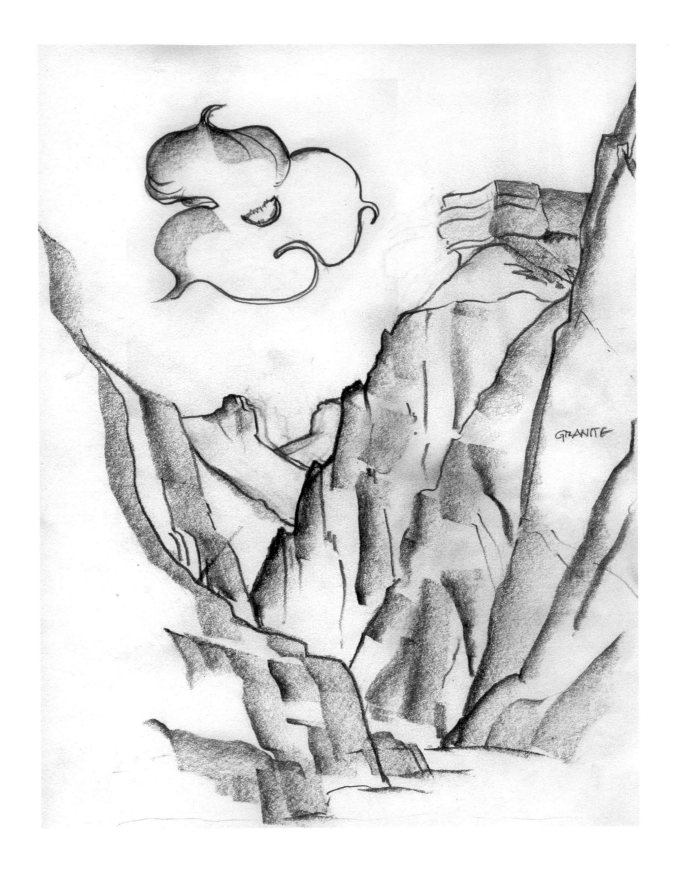

A moonflower-shaped cloud around the moon.
A moment to remember.

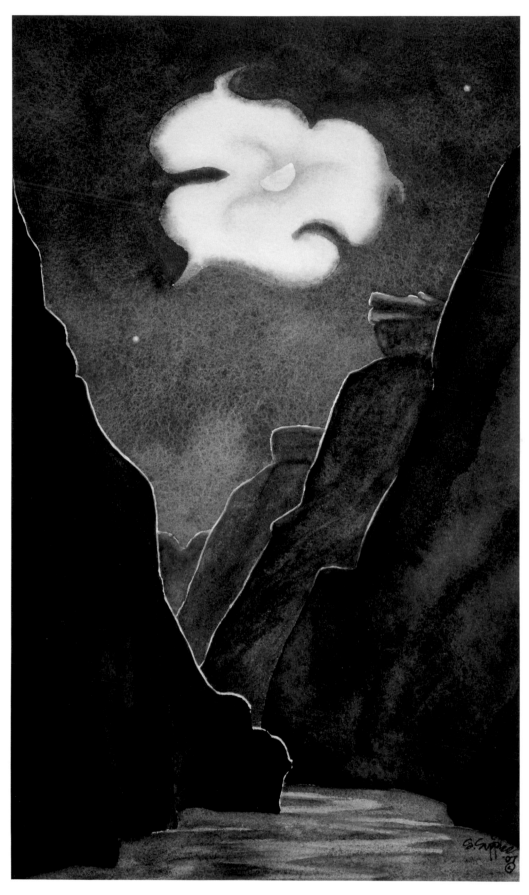

Moonflower

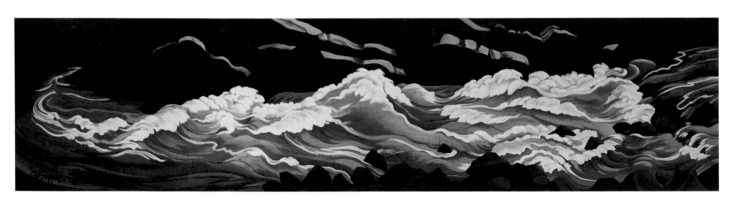

River Rapture

Rolling through the Gems.

oil 24" x 96"

TRAIL TRAVEL

canyon above
canyon below

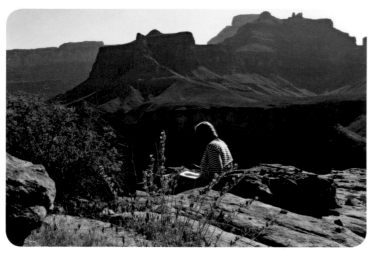

Serena backpacking on the Tonto

Starting down the Bright Angel Trail. All the enthusiasm of going into the Grand Canyon.

Spilling drinking water on this drawing didn't dampen my creative flow; this title quickly popped in my head.

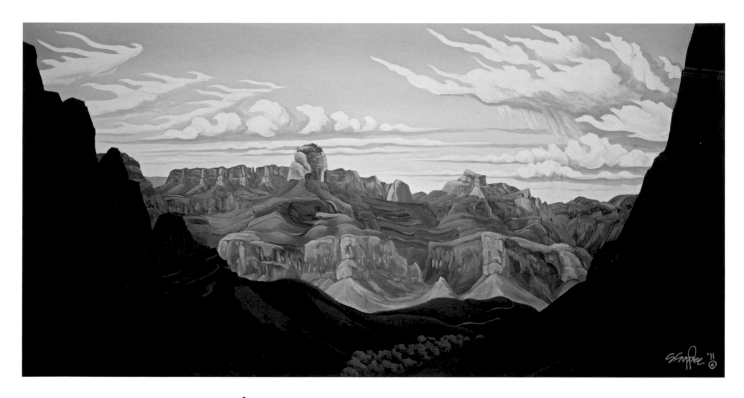

Grand Stretch of Imagination

oil 30" x 60"

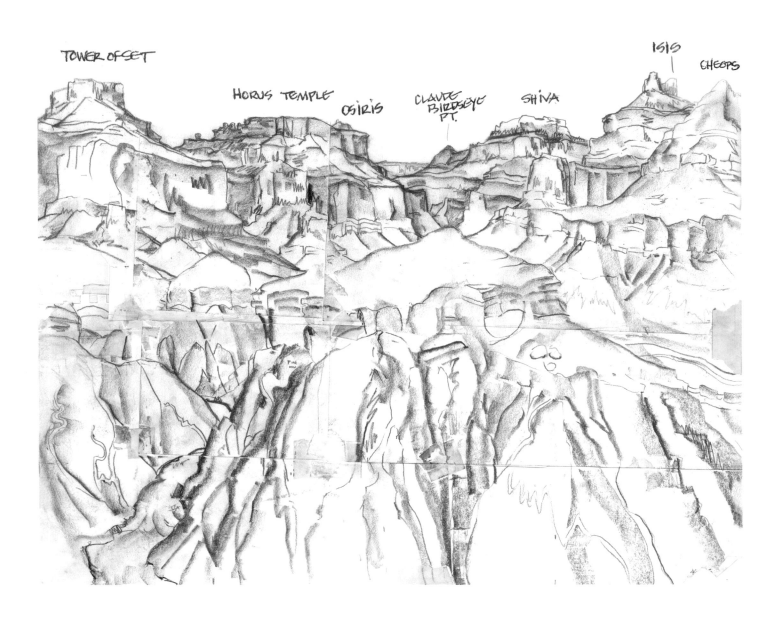

The downstream view from Plateau Point. I enjoy looking at a map and finding landmarks.

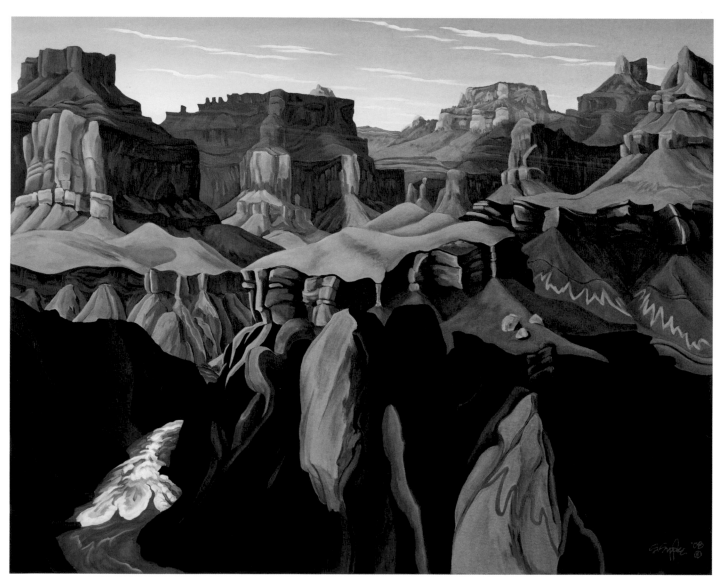

Depth Charged

oil 44" x 54"

Slipped down a gap of the Tapeats and found Horn Creek Rapid.

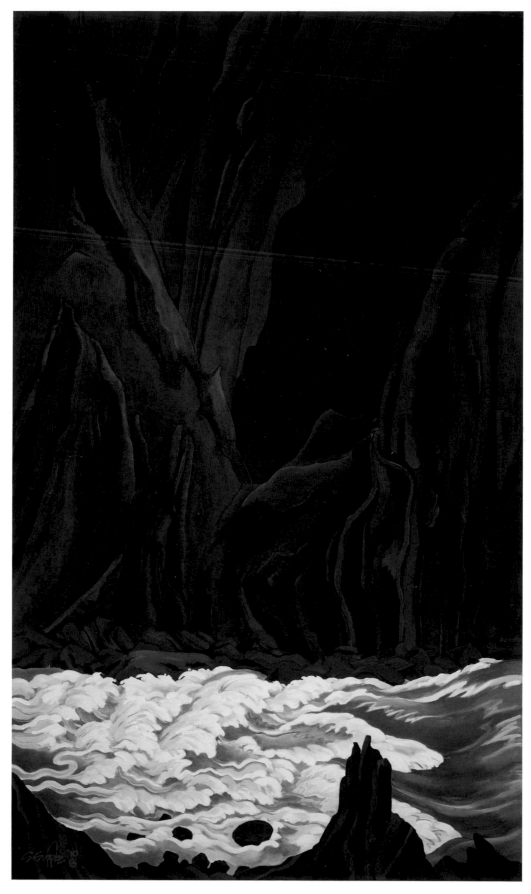

Echoing Inspiration

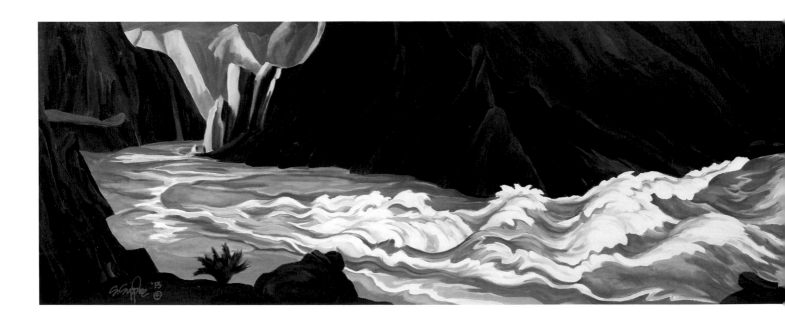

I hiked to Hermit Rapid and luxuriously spent all day drawing the rapid. Starting at the tongue, I moved from high spot to high spot downstream.

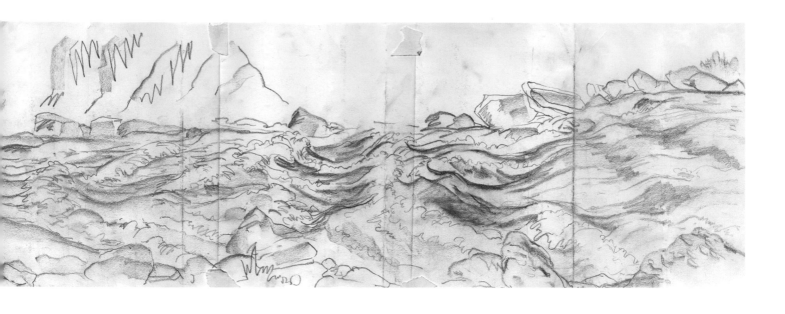

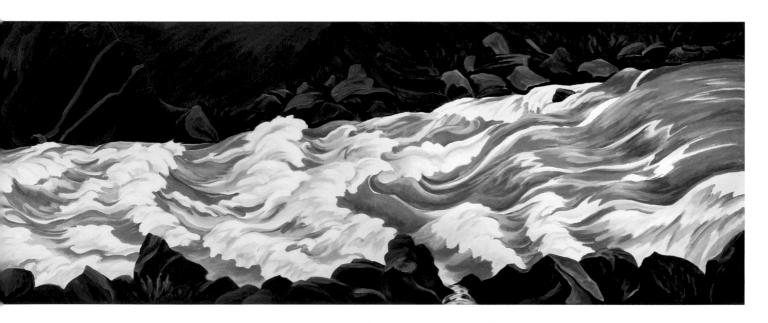

The Mighty Colorado

oil 22" x 120"

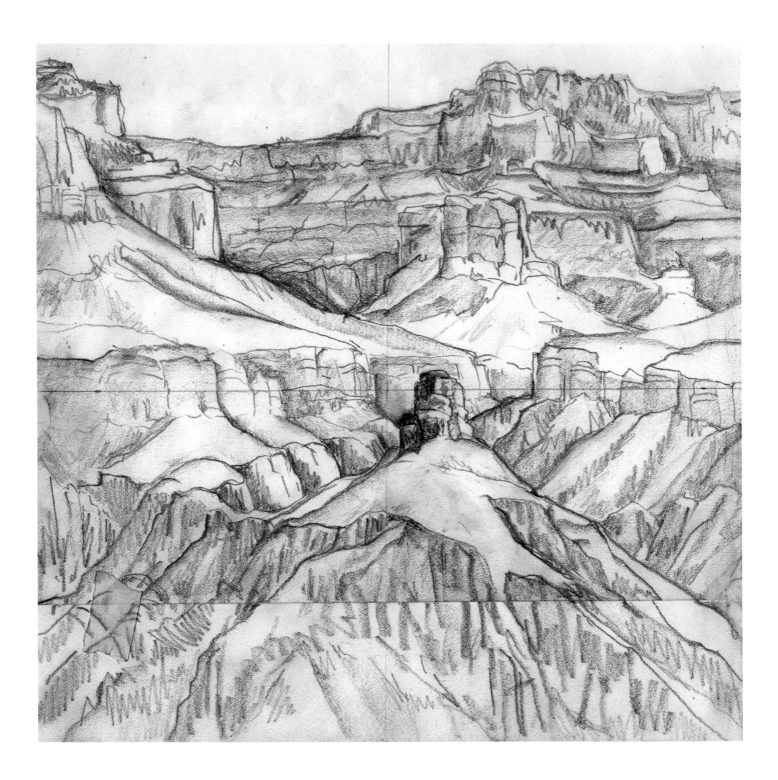

I love the views from the Tonto Platform. This is my favorite block of Tapeats between Vishnu Creek and Clear Creek.

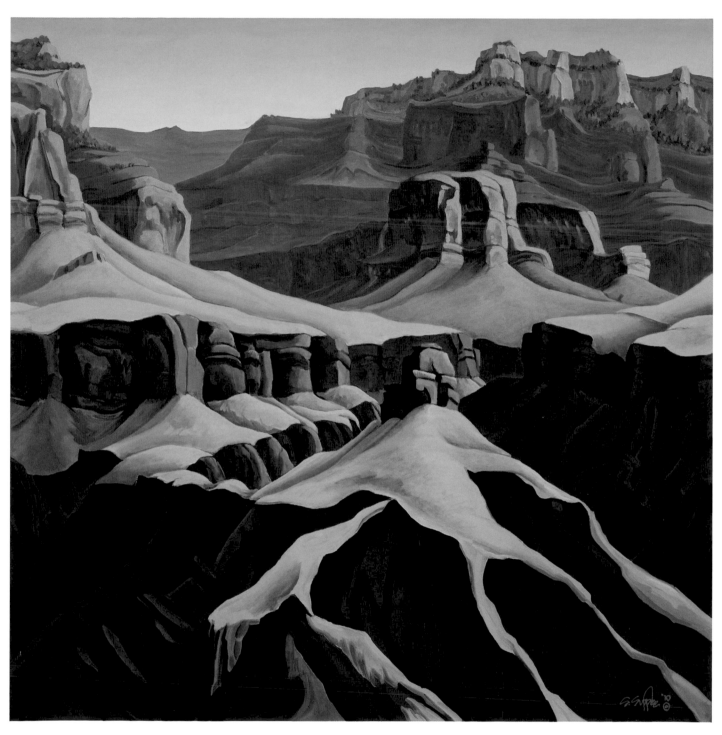

Sonata for Thought

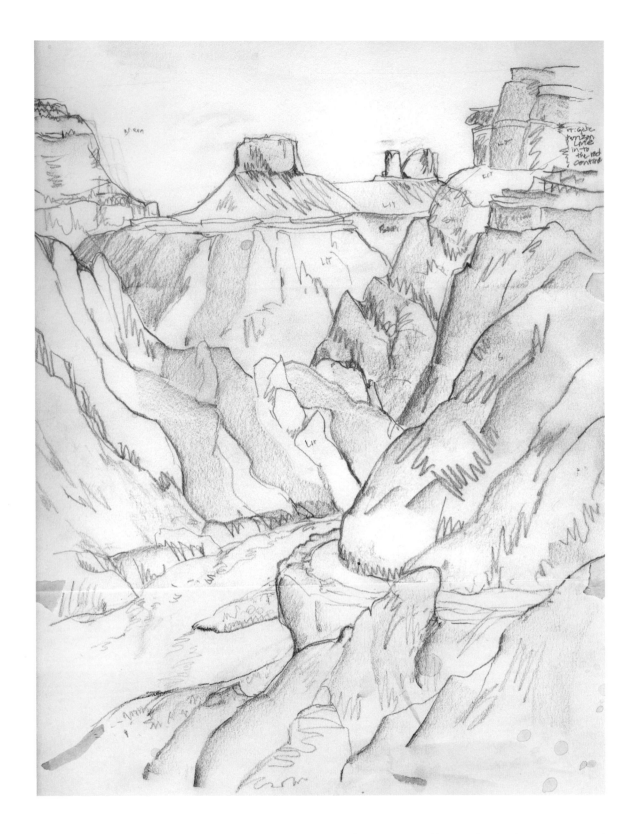

On the Bright Angel Trail toward Phantom Ranch, I discovered
a view of Angel's Gate and a spot to sit and draw.

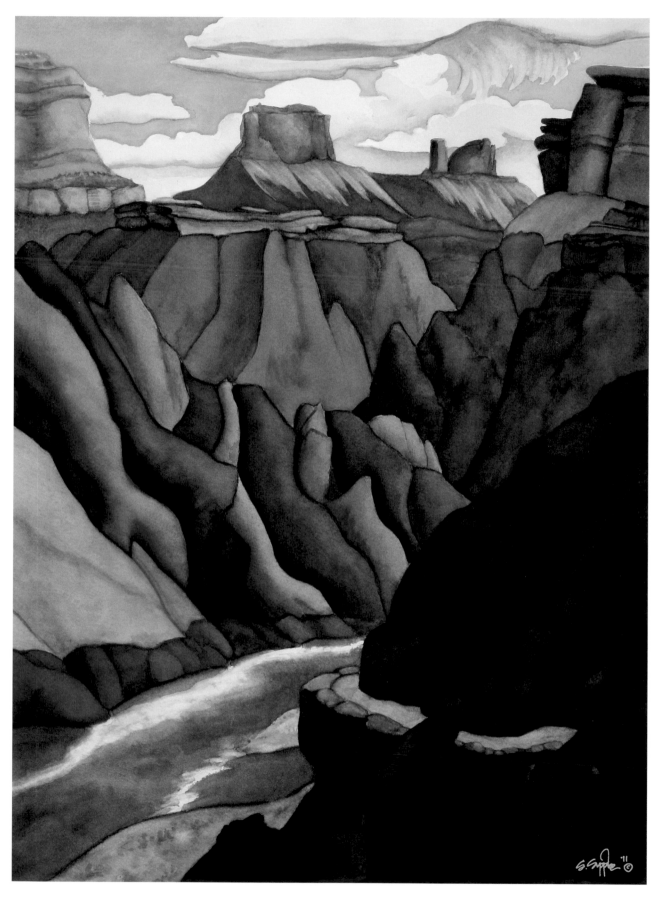

Hiker's Haven

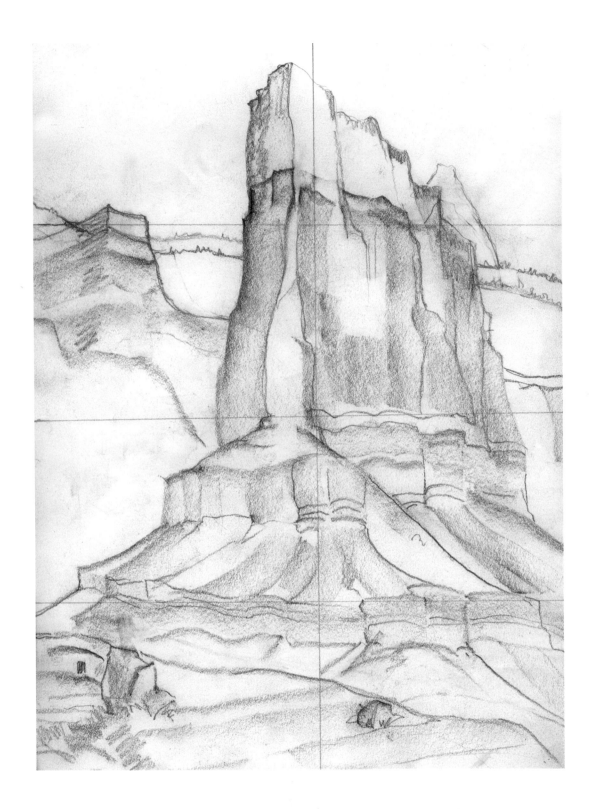

The spot of the Historic Hermit Camp, the proud buttress stands large. I painted it with heart and gave it a halo.

Drawing a grid on the sketch before starting the painting helps double check composition placement for the canvas.

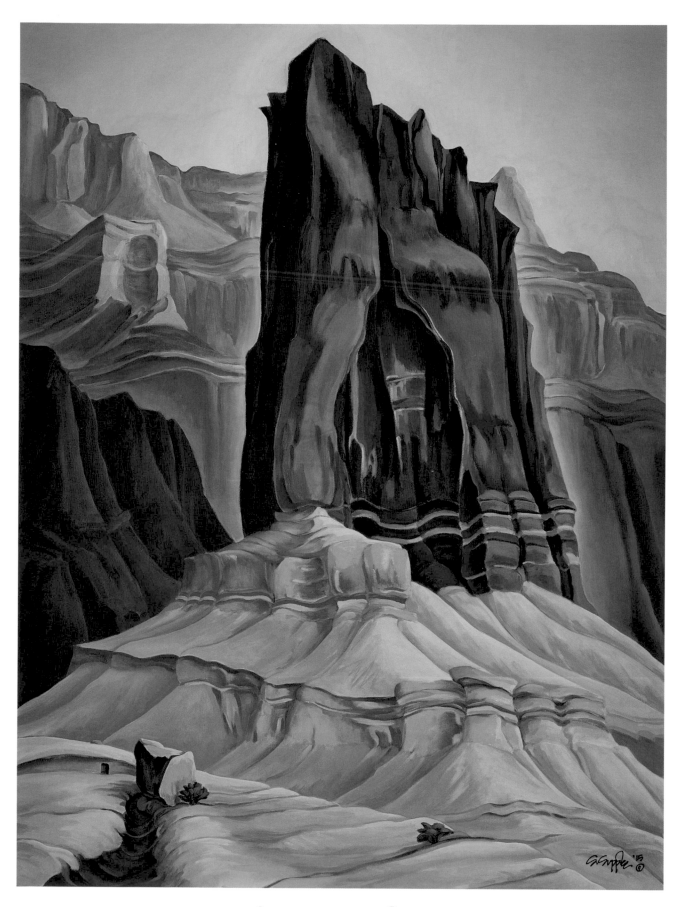

Infamous Inferno

oil 40" x 30"

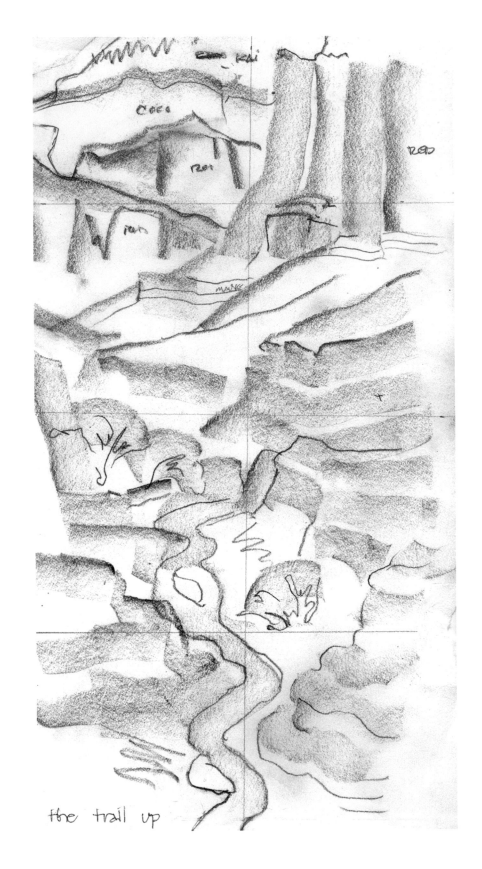

Hermit Creek, so sweet.

This drawing has notes identifying geologic layers.

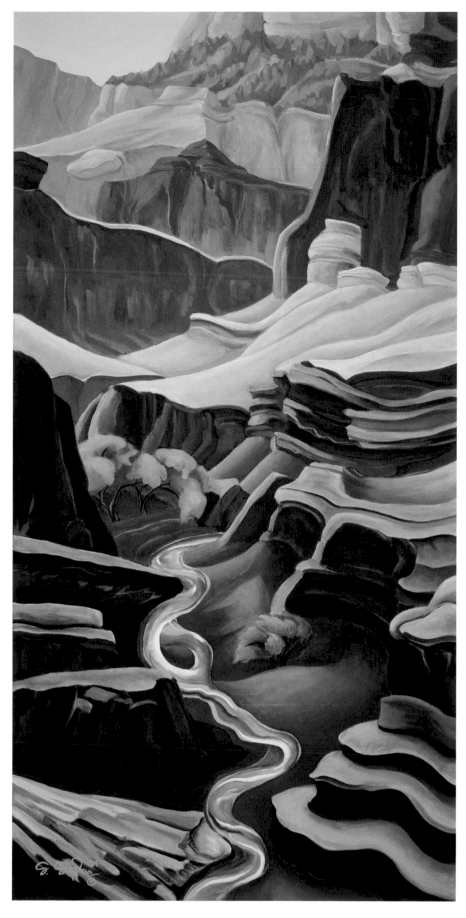

Hermit's Lair

oil 48"x 24"

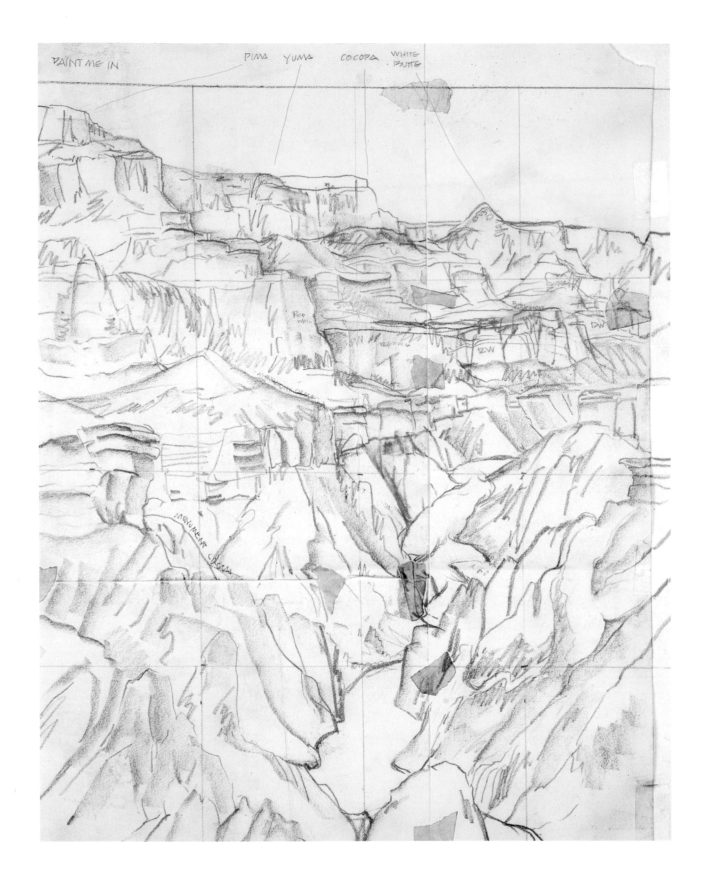

Another wonderful view from the Tonto Platform.

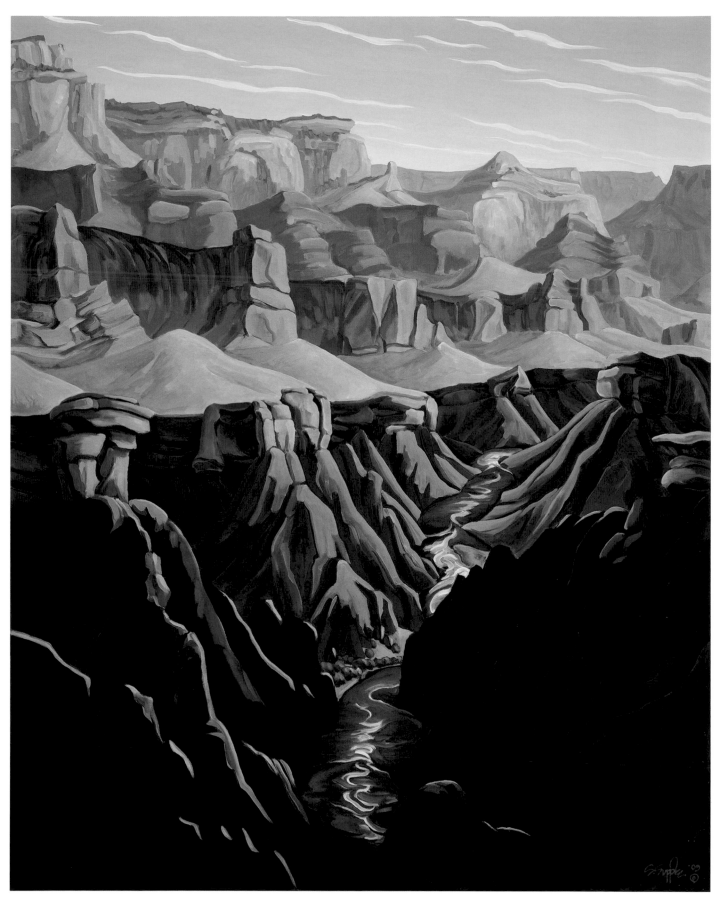

Paint Me In

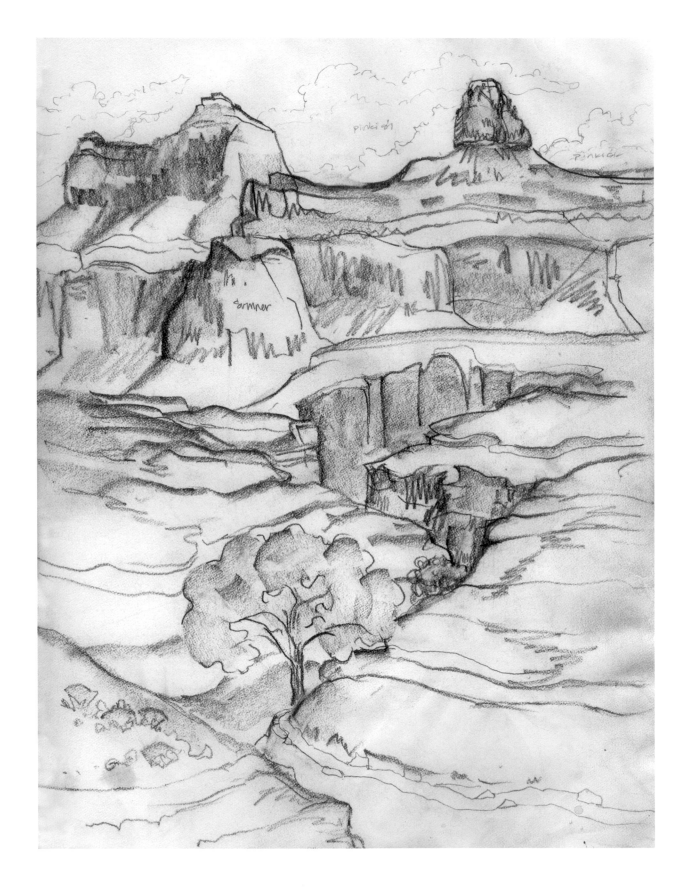

Dropping into the Tapeats Sandstone on the Bright Angel Trail.

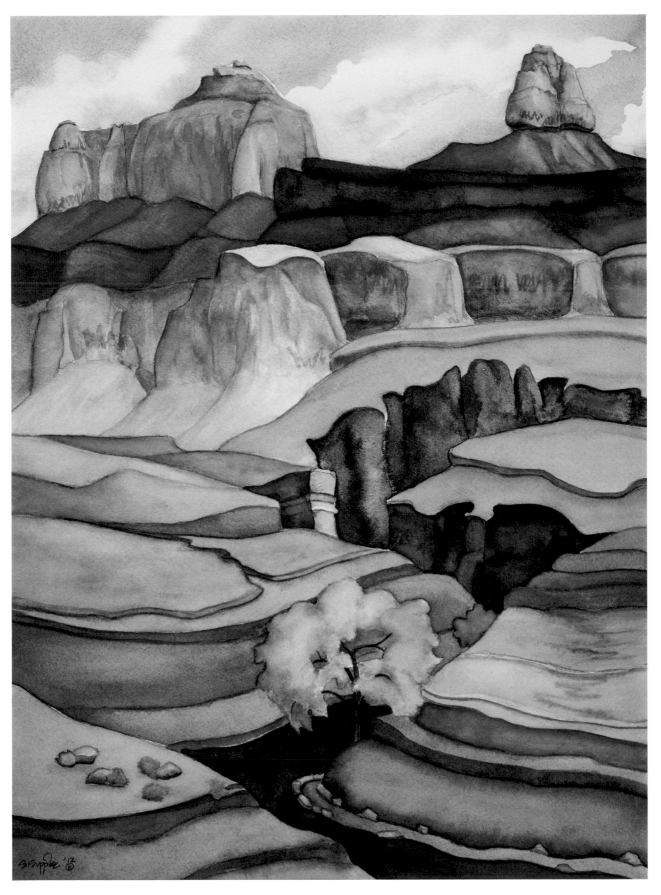

A Walk in the Park

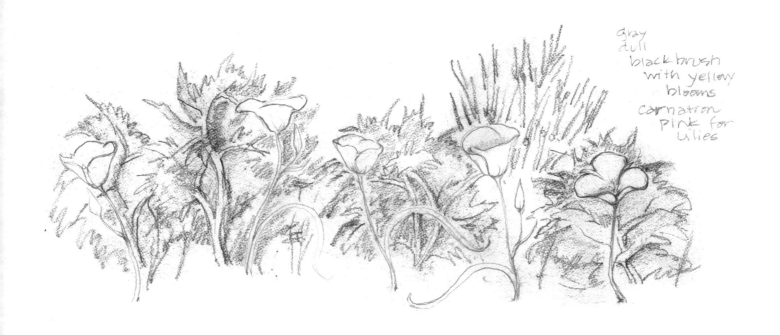

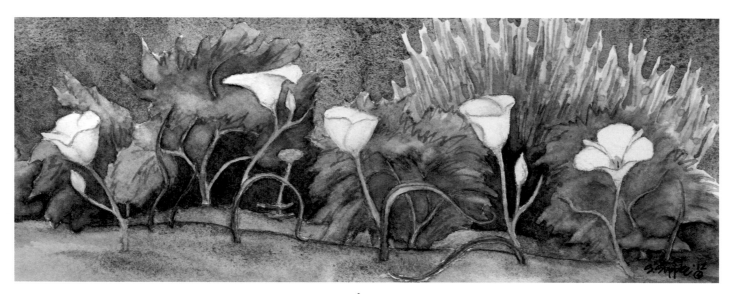

Lily Lane

Walking on the Tonto, there were lilies everywhere in the blackbrush and mormon tea. The western bluebirds joined in, enhancing my joy.

watercolor 3" x 8½"

PHANTOM RANCH
my 2nd home

winter retreat deep in the Canyon

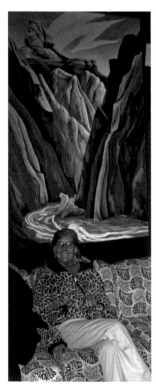

Serena with the oil
painting commissioned
by the maids and cooks
of Phantom Ranch

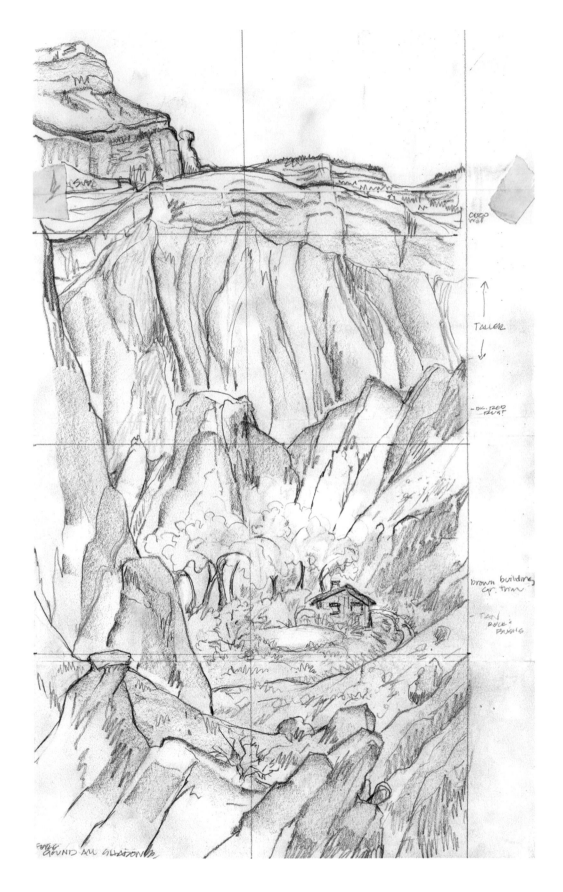

Heading up the Clear Creek Trail looking back at
Phantom, the lush oasis deep in the Canyon.

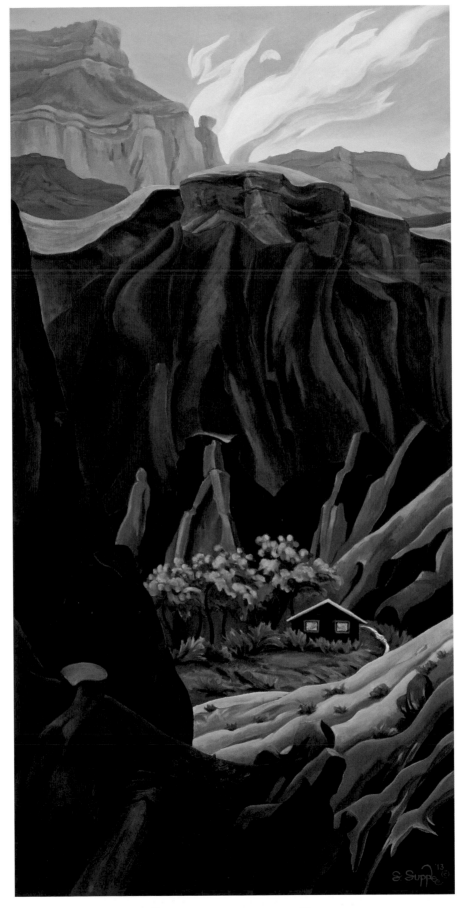

Deep Down Tradition

oil 48" x 24"

An overlook view I will love forever.

This painting is in the permanent collection of the Grand Canyon Association and Grand Canyon National Park.

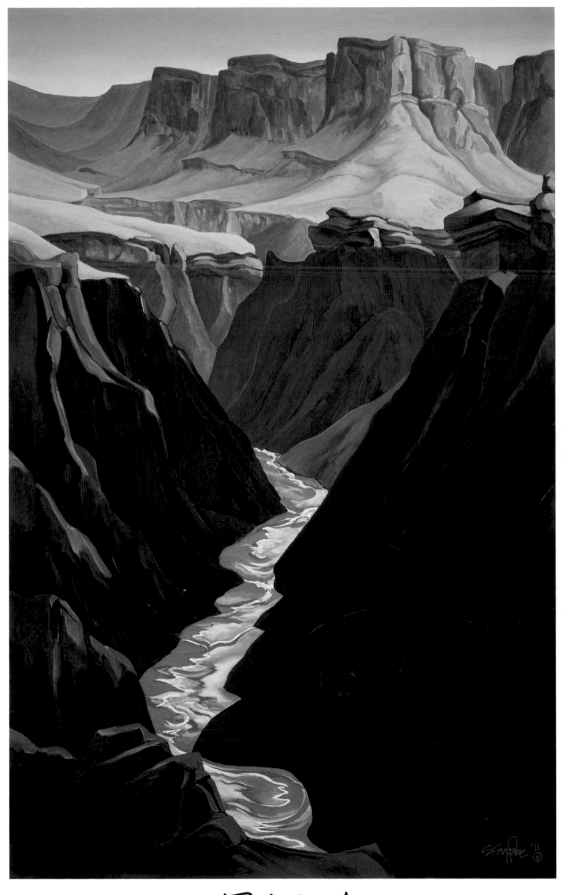

Clear Path to Awe

oil 48" x 30"

This is the National Park Service corral for the pack mules. It was built by the CCC in 1936. The Sjors family planted the center tree in 1998 on Thanksgiving.

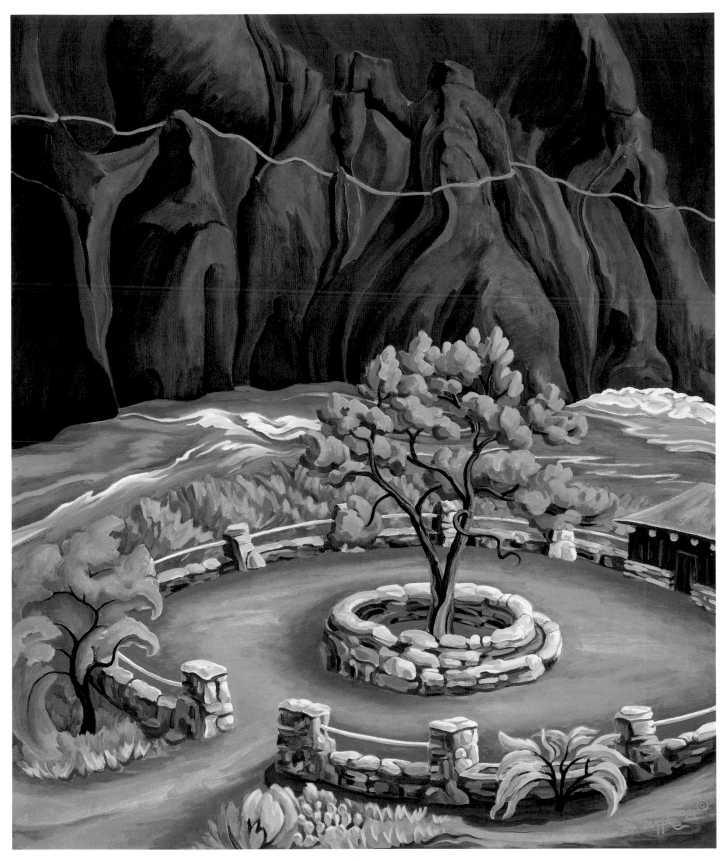

Circle Up

The cabins of Phantom Ranch are adorable. Mary Elizabeth Jane Colter did a remarkable job designing them with rocks found nearby and short boards that came down by mule. A treat to stay in after the hike in.

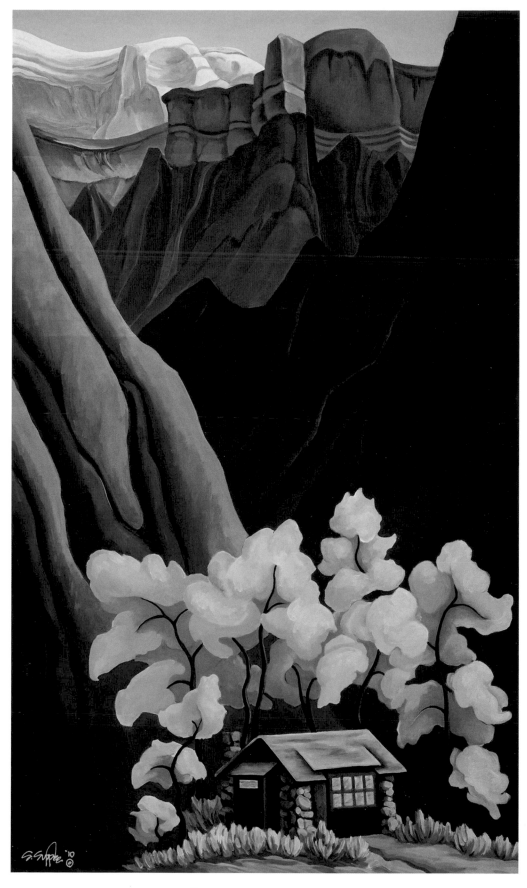

Radiant Respite

oil 50" x 28"

The Inner Gorge has playful bands of pink Zoroaster Granite.
I see it as a touching way to show tribute to Isis Temple.

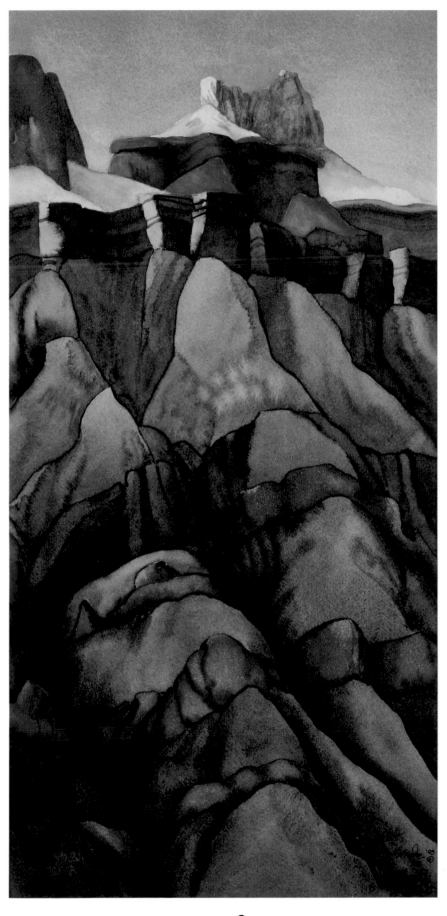

Robes of Isis

watercolor 17" x 8"

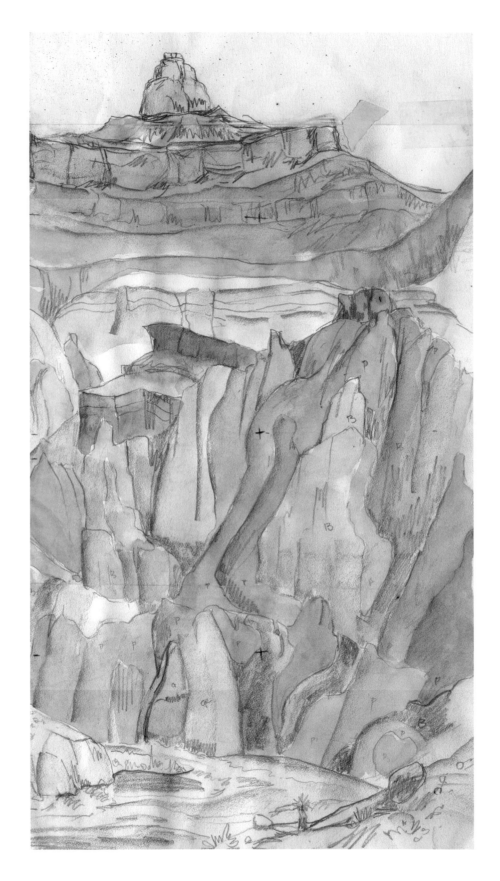

It is expansive seeing so many layers reaching up from Phantom Ranch and knowing the river played a part in forming this spectacular place.

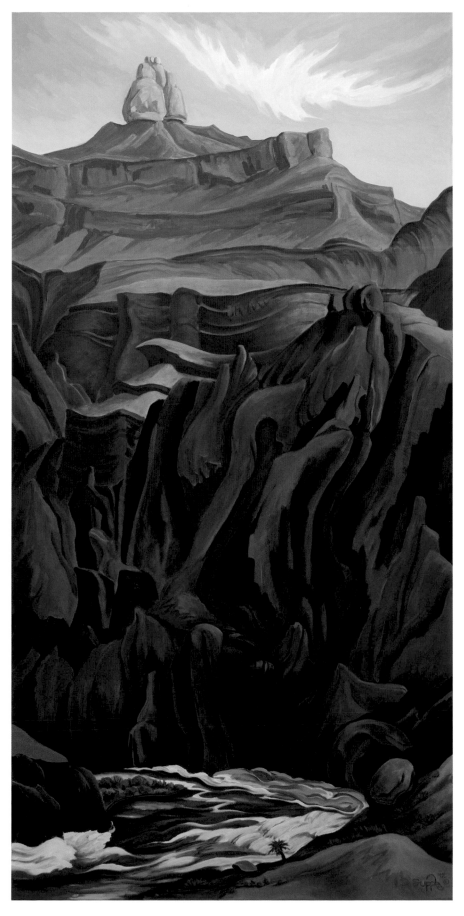

The River Did It

oil 60" x 30"

Looking at the South Kaibab Trail and where it connects with the river trail built in the 1930s by the CCC. Those who have walked or worked on these trails have stories.

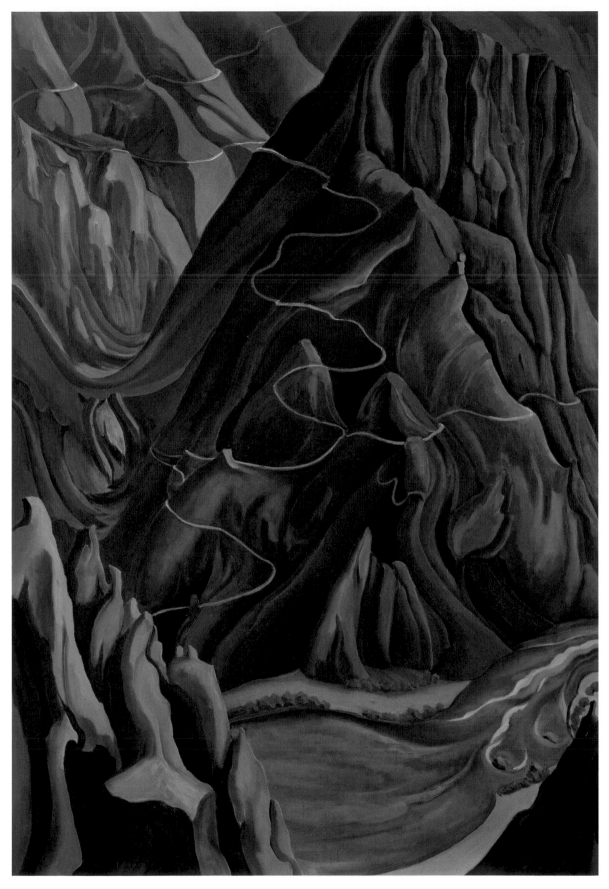

A Tale of Two Trails

oil 44"x30"

A circle of rocks to observe the Canyon. A place to plan what's next.

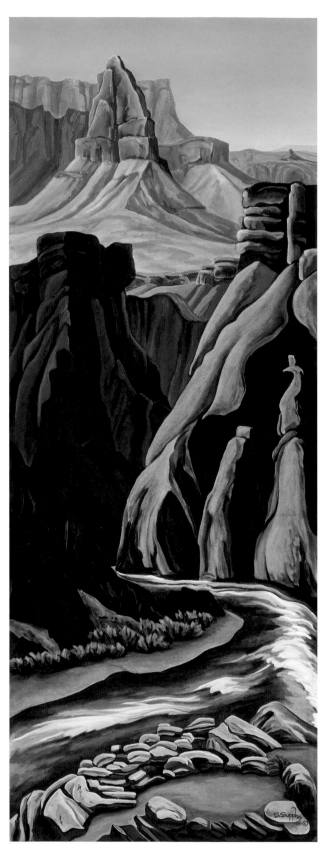

Living Impasse

oil 60" x 24"

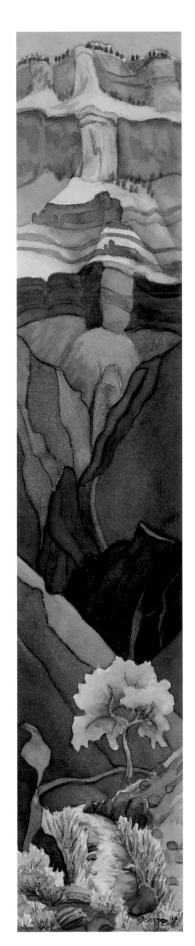

Snow all the way down to the Tapeats Sandstone. I am warm, relaxing near Bright Angel Creek. This is an experiment of capturing a thin slice of the Canyon.

4 Seasons

watercolor 18½" x 3½"

I did this painting as an ode to the cottonwood trees that shade and shelter the visitors of Phantom Ranch. As the cottonwoods die off, ash trees are being planted in their place.

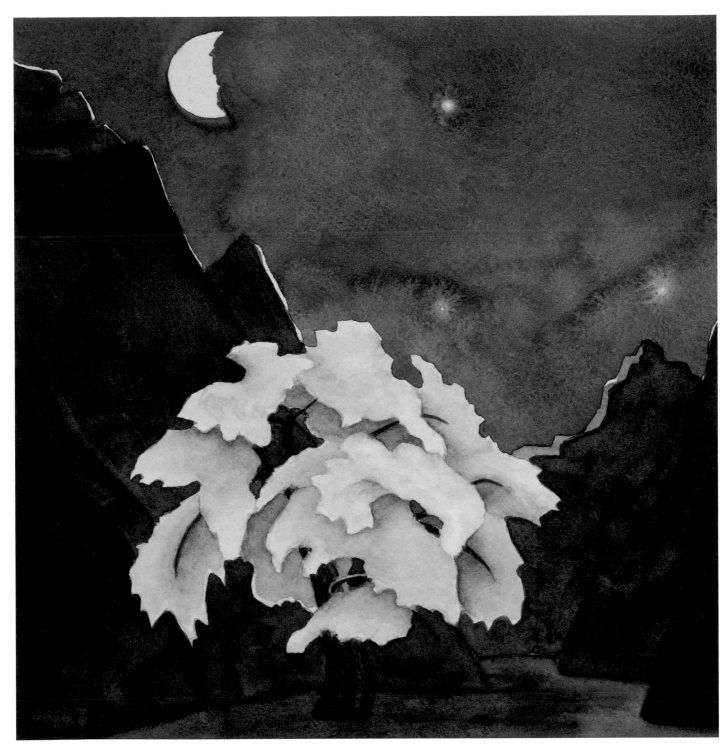

Cottonwood Candy

watercolor 7½" x 7"

An overlook above Phantom looking downstream
toward Pipe Creek, the Battleship and the South Rim.

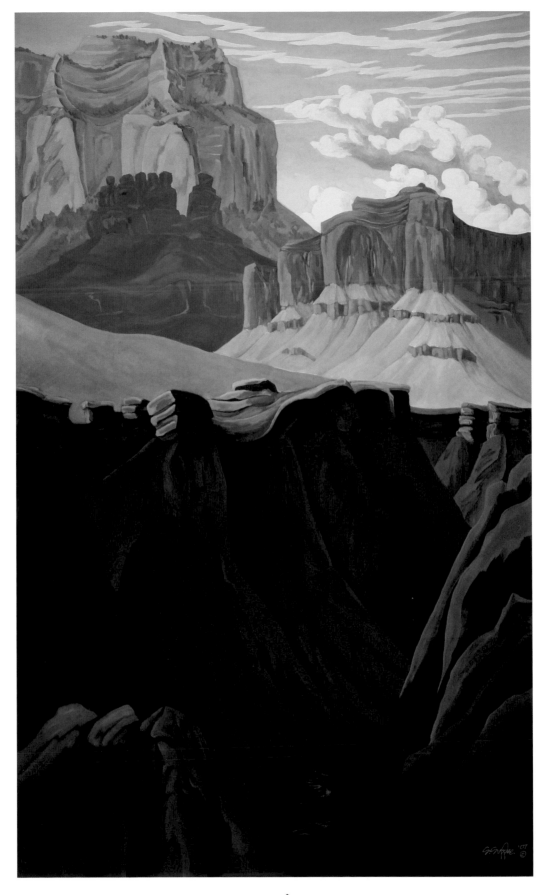

Deep in Depth

We all have our family bloodline. The red vein I painted in "Happy Spirits" represents a canyon bloodline. The kindred connection of our canyon friends is strong.

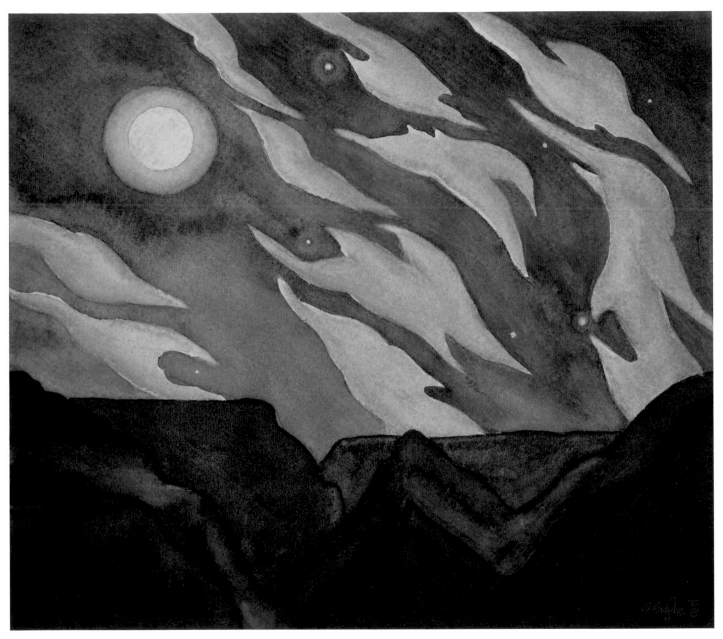

Happy Spirits

watercolor 7" x 8"

ACKNOWLEDGMENTS

I have been blessed with so many helpful hands and minds. Thanks to everyone who has purchased my work along the way, supporting me and my vision. A special thanks to all of the following people:

The Grand Canyon Association for selling my art on the rims and their enthusiasm for this new book.

The Phantom Ranchers for taking good care of my body so I have the freedom to follow my ideas.

Chris Hoge and Kopavi Rubens for hauling water on the Tonto so I would have time to draw and paint there.

Bill Godschalx and Patrick Paul René for creating beautiful digital files of my paintings to create this book with.

Duncan and Caroline Mackie for digitizing my vision of the chapters.

Patrick Paul René for having a can do attitude with my wishes.

Lulu Santamaria for her enthusiasm in guiding my book.

Della Yurcik and Bil Vandergraff for providing support when I need it at a moment's notice.

Thanks to all the folks who have captured my artistic journey with their wonderful photography.

Ginny Carlson for helping get my ideas in understandable grammar.

d'ahna for holding my hand.

Rani Derasary for bright ideas, beautifully understanding my vision as well as incredible, articulate editing.

Tom Wesson who is always there, rigging my trips and keeping my boat, my vehicles, and me in working order.

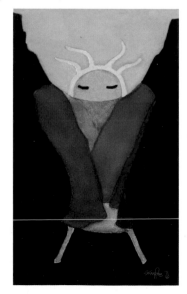